THE Art OF Watercolor Lettering

THE Art OF Watercolor Lettering

A BEGINNER'S STEP-BY-STEP GUIDE TO PAINTING
MODERN CALLIGRAPHY AND LETTERED ART

KELLY KLAPSTEIN

QUARRY

Brimming with creative inspiration, how-to projects, and useful information to enrich your everyday life, Quarto Knows is a favorite destination for those pursuing their interests and passions. Visit our site and dig deeper with our books into your area of interest: Quarto Creates, Quarto Cooks, Quarto Homes, Quarto Lives, Quarto Drives, Quarto Explores, Quarto Gifts, or Quarto Kids.

First Published in 2020 by Quarry Books, an imprint of The Quarto Group,
100 Cummings Center, Suite 265-D, Beverly, MA 01915, USA.
T (978) 282-9590 F (978) 283-2742 QuartoKnows.com

Quarry Books titles are also available at discount for retail, wholesale, promotional, and bulk purchase. For details, contact the Special Sales Manager by email at specialsales@quarto.com or by mail at The Quarto Group, Attn: Special Sales Manager, 100 Cummings Center, Suite 265-D, Beverly, MA 01915, USA.

10 9 8 7 6 5 4 3 2 1

ISBN: 978-1-63159-780-0

Digital edition published in 2020
eISBN: 978-1-63159-781-7

Library of Congress Cataloging-in-Publication Data available

Cover and Book Design: Megan Jones Design
Photography: Kelly Klapstein

Printed in China

For Walter, Sophie, and Howard.

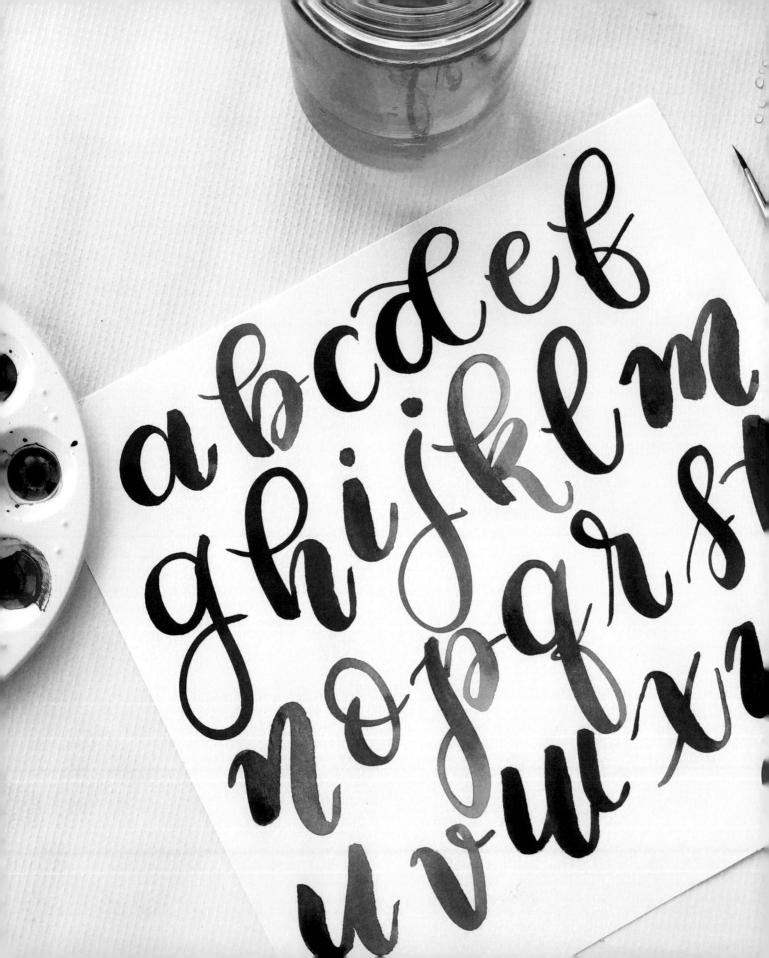

Contents

Introduction

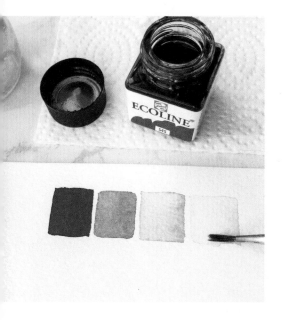

I can clearly remember art time in elementary school when the teacher would bring out the paints. Finger painting and those thick globs of color seemed too messy and indiscriminate to me. But when the tempera paint cakes and water cups and brushes landed on my desk, I felt my heart beat a little faster. The simple act of swiping paint colors onto paper was a satisfying and creative experience that brought me great joy. I didn't think of myself as a skillful painter, but I loved the feeling of being artistic with a brush in hand.

At the age of ten, I went through a paint-by-numbers phase and became obsessed with filling in the colors bit by bit until a picture formed. My mother always encouraged crafty projects and bought me lots of paint-by-numbers sets, but suddenly one day I just stopped. The paint-by-numbers project I was working on was only half finished, but I refused to continue. I think this was because I had reached the point of wanting to paint something different, something original.

I was always *crafty*, but never thought of myself as an artist—except with a pen and a big imagination. Writing has been my creative expression and outlet since my childhood. I would lose myself by filling reams of loose-leaf paper with fantastical stories, telling tales about creatures and people brought to life by my pen.

It astonishes me to think that not until this point in my adult life had I ever decided to try calligraphy or hand lettering, but when I did, I knew I had found my passion. Maybe it's the act of writing that's ingrained in my soul. When I began using water-based brush pens for lettering, I also began using them with water on watercolor paper and painting simple sketches. The colorful brush pens brought me back to those early painting days in school, and I quickly realized how much I'm drawn to the beauty of paint, especially watercolor.

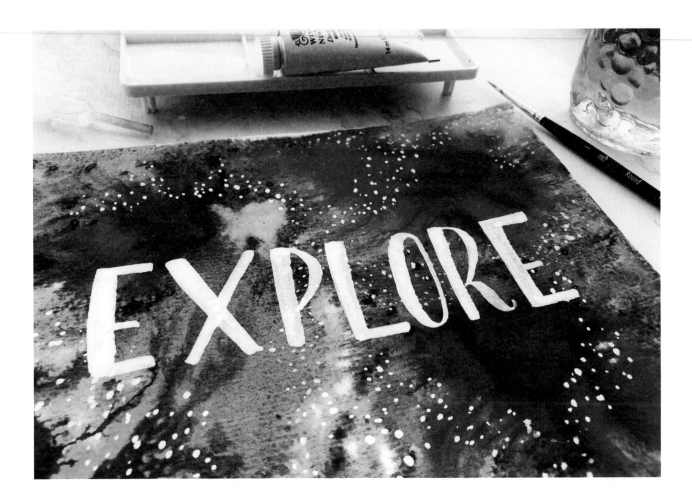

While my lettering skills with my brush pen were evolving, I bought a few good watercolor brushes and some watercolor paints and started to hand letter with watercolor. At first, I mimicked the brush pen technique. But then, I became more playful and attempted other letterforms and styles. The fluidity and unpredictable characteristics of watercolor did not deter me. They intrigued me. Somehow, the paintbrush felt right in my hand, and I was entranced with the paint colors on the paper. Combining my love of writing, calligraphy, and paint brings me to a very joyful place right here in this book. And I hope it brings you all those wonderful artistic creative feelings too.

I wish you a joyful, peaceful, and beautiful experience exploring the art of watercolor lettering.

1

What You'll Need

As with any artistic venture, having the right tools can make all the difference. When it comes to learning and practicing lettering with watercolor, there are a few important considerations, which you'll read about in this chapter. Through trial and error, I discovered which products work best for watercolor lettering and which ones didn't. There's a range of supplies to purchase for every budget, so that anyone can afford to learn watercolor lettering. Choosing the right brushes, paints, and paper will help make your learning experience easier and stress-free.

WHAT IS WATERCOLOR PAINT?

Watercolor is a paint that consists of a binder (gum arabic) mixed with pigment. The pigments can be either natural or synthetic. The first watercolor paints were derived from organic sources such as plants and minerals, some of which are still used today.

What Kind of Watercolor Paint Should I Use?

Watercolor paints are available in a range of quality levels, and I've taught with all of them. Let's be real: Can you practice with cheap children's pan paints? I say, "Yes, you can." Even I used these pans in an hour-long introductory class to watercolor lettering, but the appearance of the dried paint on the paper will be chalkier and more opaque, as compared to the lovely translucent colors we admire. However, if you're working on artistic effects, like blending colors, then I highly recommend using the artist-grade paints that are best for these techniques.

Let's take a look at the three most common options of watercolor paint used for lettering.

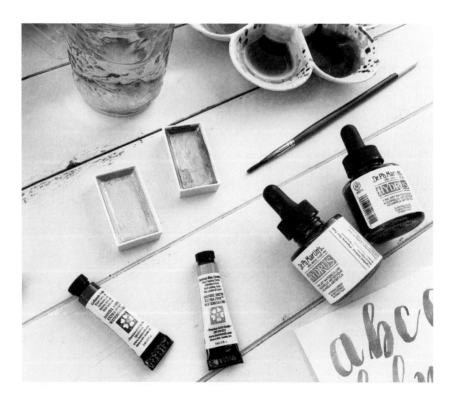

Pans or Cakes

Pan watercolors are made into dry, solid little *cakes* by compressing dried paints into individual containers. You activate the watercolor by touching the dry cake with a wet brush.

These pans seem very popular with beginner painters, especially children; however, they're the least suitable for watercolor lettering. Why? Because you need to build up a puddle of watercolor on your palette to easily paint letters. If you're painting a long quote with a solid color, you'll be exerting significant effort going back and forth from pan to palette to water cup repeatedly. Some people avoid this tiresome process by spraying, misting, or adding lots of water to cakes, resulting in tiny pools of watercolor right inside the pans. This isn't the best practice because water sitting in pans for long periods can cause the binder and pigment to separate more quickly over time.

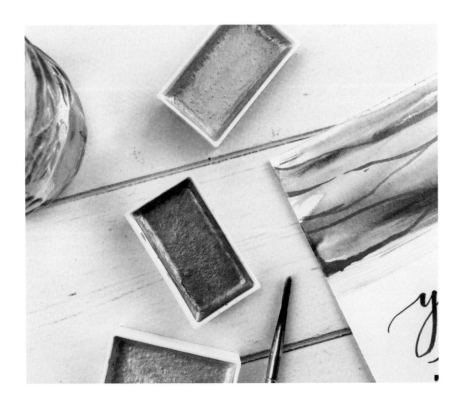

HANDLING PAINTS SAFELY

Some watercolor paints contain toxic substances like cadmium and cobalt, so take care when handling the paints and cleaning your brushes.

- Avoid using kitchen utensils, cups, and bowls as part of your watercolor tool kit unless you've designated them to use solely for painting.

- Wash any tools you use with watercolors in a bathroom, laundry room, or studio sink rather than in your kitchen sink.

- Watercolor paints should be stored in a cool dry place, out of direct sunlight.

- Make sure to screw the caps tightly onto the tubes of paint to prevent them from drying up.

Tubes

Tube watercolors, which have a toothpaste-like consistency, are a concentrated form of paint. Lots of artists build up their own pans of paint with tubes and palettes, but for lettering, we'll use the tubes a little differently: Squeeze a tiny bit of paint from the tube into a palette well, add a little water, and then mix together. A pipette is handy for adding small amounts of water to the palette wells. A toothpick or similar item can be used for mixing the paint with water instead of a brush (to avoid wasting paint) to attain the right liquid consistency and color for painting. The more water you add, the lighter the value of the color.

Since tube watercolors can be quite expensive, many artists have a number of palettes that they let dry when they're finished working. Instead of cleaning the palette, set it aside and allow the water to evaporate, leaving behind the hard, dry remnants of the paint in the bottom of the well. To use the paint again, add water to the well to rehydrate the watercolor. This can be done multiple times until all the watercolor in the well has been used.

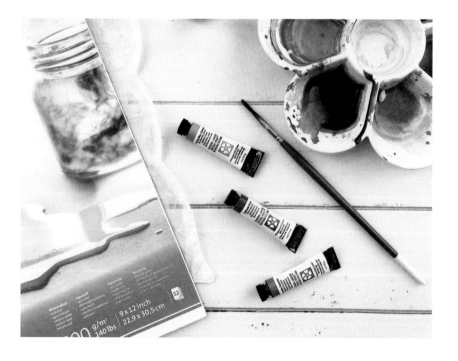

Liquids

Liquid watercolor is the ideal type for lettering. Liquid inks and other similar mediums comparable to watercolor can be found in art supply and craft stores.

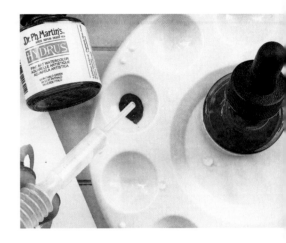

Two popular liquid watercolors are Dr. Ph. Martin's and Talens Ecoline. These are both sold in glass containers. The Dr. Ph. Martin's bottles have eye droppers, which are very handy for adding watercolor to a palette. There are several types of liquid dyes, inks, and watercolors in the Dr. Ph. Martin's line. Their Hydrus Fine Art Watercolors contain lightfast pigments, an important consideration for the longevity of your lettering projects (see "Archival Properties," below). Their Radiant Concentrated line of watercolors are dye-based and need to be shaken and diluted with water before use.

If you're unfamiliar with a brand, it's a good idea to read the manufacturers' descriptions of their liquid watercolor before using it.

Liquid watercolors can be used at full strength for vibrant, intense pigment, but most people dilute them by adding water. Using a pipette or an eye dropper, add the liquid watercolor to your palette well. Then, with a clean pipette, add water. You can be fairly "scientific" about the addition of water with a pipette and record the number of drops you add by creating a swatch to document the values produced by each dilution amount. I just estimate, do swatches, and remember the approximate ratio of liquid paint to water.

Archival Properties

After spending hours on a watercolor project, you want to ensure that your artful lettering will be framed and preserved without fading or deteriorating. If you have this expectation, then do your research and use watercolors that will stand the test of time and are *lightfast* fine art pigments. For example, Dr. Ph. Martin's has two different ranges of liquid watercolor paint: Hydrus Fine Art watercolors are lightfast and permanent; however, the Radiant line is a *dye* ink that isn't lightfast. Dye-based watercolors will fade in UV light.

WHAT IS INK?

Fine art pigment ink is often used in place of liquid watercolor for lettering. It's a popular option because of its lightfastness.

BRUSHES

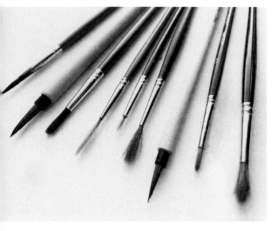

The best type of brushes I use for watercolor lettering have two important qualities: flexibility and shape.

Shape

Watercolor brushes come in different shapes and sizes, and the round brushes range from size 000 to 24. The simple rule is the larger the brush, the larger the letter forms. When we are painting larger letters with a larger brush, we need more skill and control; thus, I recommend beginners start with a smaller round brush. Most often, I use round watercolor brushes, usually size 1 or 2.

Flex

Flexibility or *springiness* is critical for lettering with watercolors because you always want to be working with a brush that has a fine point and will retain its shape when wet. A cheap plastic children's paint set brush isn't going to be used for watercolor lettering because when wet, the bristles just flop over. We want a pointed tip, not a floppy mop.

ROUND BRUSH STYLES ONLY

Italic, Gothic (blackletter) calligraphy, and Roman capital styles of lettering can be accomplished with a flat brush, but not a round brush. These styles are not covered in this book.

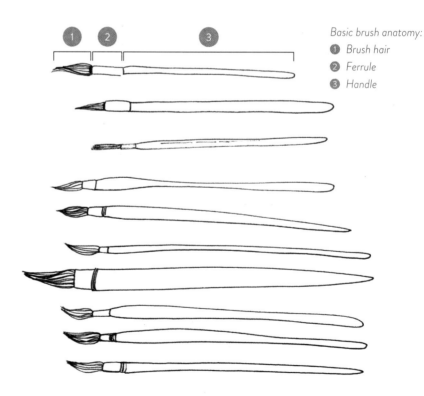

Basic brush anatomy:
1. *Brush hair*
2. *Ferrule*
3. *Handle*

Synthetic vs. Animal

Without getting into a political debate about the ethics of using brushes with animal hair/fur, the simple fact is there are lots of excellent synthetic brushes that mimic animal hair. They might not hold as much watercolor paint as a sable brush would. This means you'll be dipping into water and paint more often, which can be annoying when lettering midstroke, but honestly, I find working with synthetic brushes is just fine. Sometimes, the nylon bristles are preferable because of their *springy* flex and many people enjoy them for this quality. Not all synthetic brushes are created equal, so finding one that you like most might be trial and error.

Water Brushes

The water brush is a modern tool some artists use for painting and lettering. It's become popular with hand lettering artists because of the nylon bristle tip rather than the water chamber. The water brush has a built-in water chamber for convenience, so the idea is to just squeeze it and continue painting or lettering with the water source coming through the bristles instead of stopping and dipping. However, I find that I like to control the water volume myself with a regular brush because the flow from the water brush isn't easy to regulate. I've used empty water brushes similar to the way I would use a regular brush. I do like my brush to have a very fine tip, and sometimes the tip of a water brush isn't fine enough for me. I recommend trying a water brush and deciding for yourself.

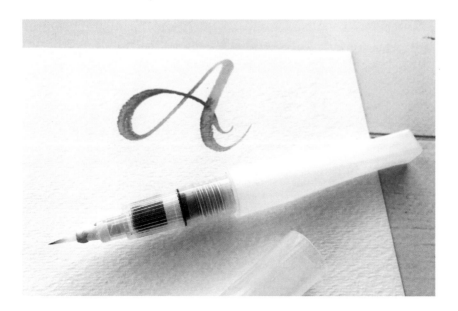

TIP: If you can lay a brush's wet bristles down flat and they return to a point when they're lifted up from the paper, this indicates that it's a good brush for lettering.

Storage & Cleaning

The number one rule for brush maintenance is not to leave them soaking in water. Rinse your brush well in clean water when finished and then gently squeeze bristles with cloth or papertowels and lay flat to dry. If you dry them standing up vertically in a cup, there's a danger of the water moving downward into the ferrule (the part that holds the bristles to the handle), which will then rust or loosen around the bristles.

Of course, we don't store brush tips down because that will bend and damage the bristles. After my wet brushes are cleaned and dry, I put them in a cup. A canvas brush roll is another nice choice for storage. Any type of storage that is protective of the bristle tips is suitable.

WATERCOLOR PAPER

TIP: Smooth watercolor paper is better than rough.

You can find watercolor paper in every art supply store and also in craft stores. Watercolor is a medium that's now found in the world of crafting, not only fine art, so the paper is very accessible.

The ideal choice of substrate (painting surface) for watercolor lettering is watercolor paper. There are so many brands that are suitable, but overall, smooth paper is better than rough. Smooth paper allows for finer manipulations of letterforms. A rough paper with more texture, or *tooth*, can affect the movement of your brush on the surface so your lines aren't as clean; however, painting on rough paper might work for some lettering styles where the texture can add interest to the finished project. (For more options, see Other Substrates, page 22.)

What Is Watercolor Paper?

Most watercolor paper is made of wood pulp and cotton. Some expensive papers are 100% cotton, and there are artists who use this exclusively. Having more cotton content means the paper will be more absorbent without buckling or warping.

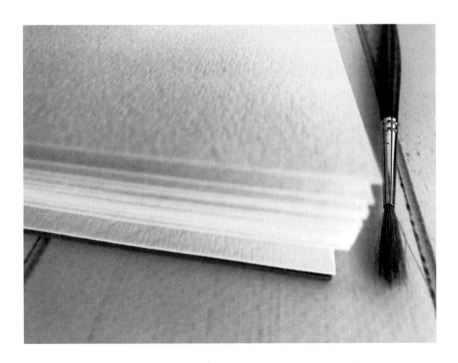

Sheets, Blocks & Pads

Watercolor sheets can be purchased individually, but these are usually the more expensive cotton papers. I usually work with blocks or pads. There are also rolls of paper, which I don't use. Lots of watercolor paper pads come in a book with a coil, which I also don't like to use because it's more difficult to remove a single sheet, and my preferred method is lettering on a single sheet on the table.

A **watercolor block** is a glued stack of paper that is adhered together along all sides, which makes it unnecessary to stretch your paper before using it. (*Stretching* means to soak a sheet of paper in water for 5 to 10 minutes, then mount it to a board to dry with tape or staples.) The block helps prevent warping when a lot of water is used. The downside of a block is that if your hand rests on the paper you'll encounter the edge of the block while writing and lose stability. If you use a block, then you'll letter on the top sheet of the block and remove the single sheet from the block with a craft knife or a similar tool after the lettering is dry. I've also removed a single sheet of paper from a block and used that single sheet for my lettering. *When removing paper from a block, be careful not to tear it.*

My preference is a good-quality **pad of watercolor paper** that's gummed along one edge only and allows for easy removal of a single sheet. If the paper doesn't warp too much or I'm not using a lot of paint and water, then I won't tape down my paper to the table or stretch it. If my lettering involves a lot of blending colors and wet-on-wet technique, then taping the paper or using a block is helpful to prevent warping. I never make an effort to stretch the paper, but you can certainly do so.

Weight

The weight or thickness of watercolor paper is numbered in *lb* (pounds per ream) or *gsm* (grams per square meter, or g/m²). The three most common weights are 90 lb (190 gsm), 140 lb (300 gsm), and 300 lb (638 gsm). Since there are variations of thicknesses in the pound measurement, check the gsm when choosing the paper. Also, thicker paper isn't necessarily better for lettering because some thick papers are too absorbent. For watercolor lettering, we like the paint to sit on the surface longer and not be absorbed quickly. Watercolor paper has external and internal *sizing*, which allows paint to be absorbed but not spread uncontrollably.

In general, I usually use 140 lb paper, and I don't stretch it because I'm not using heavy washes. Also, using a gummed pad or block lets you avoid having to stretch it. Since we're addressing watercolor lettering as opposed to painting, we won't discuss the stretching paper technique. You can use lighter weights, such as 90 lb, but then you risk the paper warping.

Climate

Humidity is a factor to consider when using watercolor. If you're in a dry climate, the paint obviously will dry quickly and fixing mistakes or creating a certain effect by lifting (gently removing) or manipulating paint will be more difficult. On the contrary, painting in a moist, humid climate means the drying time is slower, so manipulating the paint and lifting is easier. The sizing of the paper affects absorbency rates too. External sizing is an outside coating of gelatin or starch on the paper, which means the water will sit on the surface of the paper longer and the paper will be less absorbent. This is an important consideration with watercolor lettering because absorbent paper won't allow us to achieve certain effects, such as blending colors in the wet-on-wet technique (see page 58).

Textures

There are three main textures of watercolor paper: hot pressed, cold pressed, and rough. Cold pressed is usually more reasonably priced and popular among artists; however, I prefer hot pressed paper because it's smoother. When you're painting letters, especially in a brush script style, it's important that the bristles glide along the smooth paper and not catch on the uneven texture or be slowed by the friction of rough paper. I've also used cold pressed paper with good results. There are so many brands of paper and each one is slightly different, so it's a good idea to try quite a few and discover which paper you prefer. You can use either side of a piece of watercolor paper, and there might be a slight or significant difference between the two sides. Often, I'll use the smoother side of a cheaper cold pressed paper.

OTHER SUBSTRATES

A substrate is a surface to which paint is applied. There are a number of options to use for watercolor lettering aside from watercolor paper. Let's look at some of them.

YUPO

YUPO is a waterproof synthetic paper that is becoming more popular among watercolorists because the effects of the paint drying or *evaporating* makes for some unusual results. One perk about using YUPO is that you can easily fix your mistakes by wiping off the watercolor since the paint sits on the surface for a longer period, but the challenge is not to smudge or smear the wet colors as you're lettering. Also, YUPO has to be handled carefully because the oil on your hands will create a *resist* on the paper and your paint won't adhere to those areas.

Canvas

If canvas is going to be used for watercolor lettering, then it has to be prepped with *watercolor ground*, a primer that forms a paper-like background on the surface of the canvas after it dries. In fact, watercolor ground will allow you to paint with watercolor on a multitude of surfaces, such as fabric, glass, metal, wood, and more.

Watercolor Art Board

If you're looking for a unique surface for your final projects, watercolor art board is an interesting alternative. It's a clay surface that is archival and acid-free and absorbs watercolor paint like paper, but the pigment remains quite vibrant. This is an expensive option when compared to watercolor paper, but it doesn't need stretching and won't warp, tear, or shrink.

Illustration Board

Illustration board is really thick, like a heavyweight cardboard, which comes hot pressed and cold pressed, with little texture. Its smoother surface is nice for watercolor lettering. Since it's an expensive option, it should be used for final projects.

Bristol Paper

I often use smooth Bristol paper for lettering projects that involve water-color and other mediums like pen and ink because drawing on the smooth surface is preferable. Bristol paper is sold in a pad and is also dense enough to sustain wet mediums without warping, but it doesn't allow for as much volume of water as watercolor paper. Bristol paper also comes in solid black, which is nice when using specialty pearlescent or metallic watercolor paints that pop on dark papers.

Regular Lined Paper & Graph Paper

Practicing your watercolor lettering skills, whether it's alphabets or words, always should take place on lined paper. You could draw pencil lines with a ruler on watercolor paper, but I like less expensive options for practice. When I teach workshops, we use regular lined or graph paper to study letterforms and technique. Using regular paper is a very cost-effective way to practice, but the wet-on-wet techniques and blending of colors need to be practiced on watercolor paper. You could also download graph papers for this practice, which I offer on my website (www.kellycreates.ca/free-worksheets).

Artificial Paper

Have you seen those small specialty *Buddha Boards* that come with a brush and you use water to make strokes that dry? It's like a reusable piece of paper! Kuretake has a practice sheet like this that is useful for lettering with water. The wet strokes appear dark and then lighten until they disappear when completely dry. I've used these artificial papers, but I find the drying time a little slow. I suppose it's ironic that I'm impatient when practicing with these drying boards, but if I had a few of them to work with at a time, that would probably work best for me.

Like all my lettering practice papers, I use both sides and then put them into recycling. Hand lettering is an art form that can be considered unfriendly to the environment, so I do my best to minimize waste when practicing.

OTHER SUPPLIES

Palette

A palette is important for watercolor lettering because you need something to hold the liquid watercolor. A popular choice is an inexpensive white plastic palette that has six to ten wells that hold the paints, especially since we are often using more than one color. The number of wells isn't that important because you're probably not going to letter with more than six colors at a time. My plastic palettes usually have eight to ten wells. White palettes are best because you can see the true color of the paints inside the white wells. The plastic palettes are also a good choice because you can reduce paint costs by letting the paint dry in them and then reactivating or rehydrating with water when you want to paint again. They can be stored stacked up with dry paint in them for quite a while. There are also ceramic palettes that are nice to use because they are heavier weight and less likely to flip over or be bumped and spilled.

Pencil, Eraser & Ruler

A lettering artist's powerhouse tool kit consists of the humble pencil, eraser, and ruler trio. You can sketch your design, practice your letterforms, draw guidelines, measure quote layouts, and more. Keep in mind that pencil marks will usually show through transparent watercolors on paper, and they can't be erased when they are under paint. To avoid this issue, use a LightPad or light box to follow and paint your final lettering design using the good draft as your guide below.

Any pencil that is easily erased can be used. Be careful when erasing on watercolor paper. Sometimes, the eraser can leave a resist behind, which means the watercolor won't take to the paper. Some artists prefer a kneaded eraser, but I've also used a regular latex eraser.

My preference for rulers is a metal one because I want my lines to be perfectly straight and sometimes the plastic rulers don't *measure up*!

Painter's Tape

Securing your watercolor paper to the table is important if your water volume application is high. This will help avoid warping, especially with certain qualities of paper. Tape on all four sides. Let the lettering dry completely before you carefully remove the tape. Tape can be found in most art supply stores and also paint stores, but there are many qualities and varieties of masking tape, such as artist's tape, drafting tape, and washi tape. It's a good idea to test the tape out with watercolor if you plan on the paint coming into contact with the tape.

Masking Fluid

Masking fluid, also known as liquid frisket and drawing gum, is used to create a resist on watercolor paper. You can create some awesome lettering effects if it's used correctly (see Masking Fluid & Masking Pens on page 84). If you're using it from a bottle with a brush, then clean the brush immediately and quickly after finishing or the fluid will dry and the brush will be ruined. There are alternative applicators that are made from wood and silicone, which will avoid the sticky bristles problem.

Another popular option is the masking pen, which is basically a pen that distributes masking fluid while you're writing or drawing with it. As you apply pressure to the tip on the paper, the masking fluid flows out. There are different sizes of tips depending on what your project is.

TIP: Apply masking fluid slowly for solid coverage. Remove it by rubbing gently with fingertips or with a kneaded eraser.

Water Cups

Many watercolor artists use two cups while painting: a clean water cup and a dirty water cup. This means that when they're switching colors, they'll clean their brush in the *dirty water*, and when they need to add more water to their letters, they load up in the *clean water* cup. I find that by doing this I end up with two dirty cups, so I often use one cup and change the water frequently. Regardless, if you're using dirty water to paint, then you'll be contaminating your paint colors and they will be off or muddy. I like to see my water, so I use small glass jars and fill them three-quarters full.

Paper Towel & Rags

A very handy "eraser" of watercolor paint is the paper towel or rag. Rags are the more environmentally friendly option because you can wash them and reuse. Just make sure it's a cotton or fabric that doesn't release lint or fibers. If you make a mistake with your lettering, you can often erase that mistake completely by quickly dabbing or picking up the paint with the paper towel or rag. These cloths are also handy for offloading excess water from your brush, drying brushes, and cleaning up spills.

2

Getting Started

One of the reasons I love teaching watercolor lettering workshops is that you don't need any experience at all. It doesn't matter if you haven't painted before, held a brush, or drawn letters.

When I first started using watercolors, I realized that you can paint pretty letters quite easily without taking a formal watercolor class, but it's very helpful to understand a little about color theory, practice a few different brushstrokes, and create value scale swatches. With this information, you can avoid mixing tones that yield muddy results and instead learn how to achieve lovely hues on your paper. This book isn't about all the technique and terminology of painting with watercolor, but I share basic knowledge to help you appreciate this wonderful medium.

In this chapter, we also do some creative warm-up exercises to help you get well acquainted with your brush and feel more confident.

MIXING COLORS

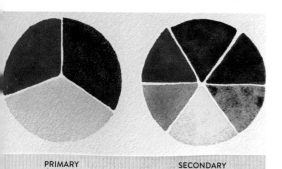

PRIMARY SECONDARY

*The colors in the **primary** wheel are red, yellow, and blue. The colors in the **secondary** wheel are the three primaries plus the three secondaries—orange, green, and purple— each of which is a mixture of the two primaries on either side of it.*

You may have already heard about color wheels. They're the standard guide to understanding color theory and to mixing or organizing colors in any medium, not just watercolor. Here, I present color mixing as balloons for you to paint, so you can fully experience how to combine colors instead of just reading about it.

Color Wheel Basics

There are three categories of color: **primary**, **secondary**, and **tertiary**. For watercolor lettering, we'll focus on the primary and secondary color wheels. Do you have to memorize this? No, but if you have trouble mixing colors for lettering in the future, you can refer to this information.

Exercise: Color Mixing Balloon Bouquets

Let's learn how colors mix together by doing this simple exercise of painting balloon bouquets, which are an easy way to apply color theory. Why balloons? Every time you paint a curved shape or line, you're practicing your skills for lettering.

You can draw outlines of the balloons with a pencil or black permanent marker first or just paint the shapes without outlines.

Yellow + Red = Orange

1. Paint a yellow balloon to the right. Paint a red balloon to the left, leaving space in the middle for an orange balloon.

2. Mix yellow and red in your palette to make orange or paint a yellow balloon in the middle and while still wet, drop in red and blend to make orange.

3. Repeat this process to fill your paper with yellow, red, and orange balloons, experimenting with different amounts and dilutions of red and yellow.

4. When dry, add balloon strings with paint or draw them with a black marker. (I drew my strings with a fine-tip permanent pen.)

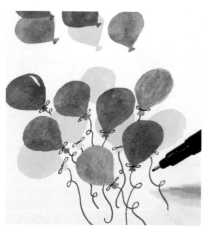

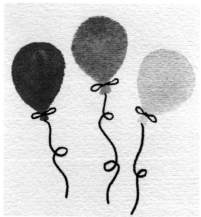

Yellow + Red = Orange

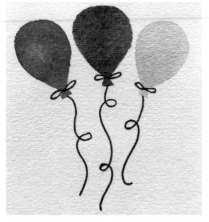

Yellow + Blue = Green

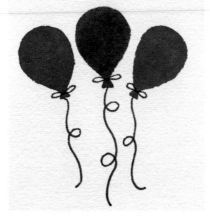

Red + Blue = Purple

Repeat these steps to mix balloons in two more secondary colors: Yellow + Blue = Green and Red + Blue = Purple.

If you'd like to explore mixing these colors further to add the **tertiary** hues—which are mixtures of a primary plus one of the secondaries that sits on either side of it on the wheel—then use your palette wells and add color to them.

Special Blends

To be honest, I don't mix a lot of colors when doing lettering because I'm not starting with only the three primary colors of watercolor paints. Usually, I have a whole set of tubes or liquid watercolor bottles in a wide range of hues that I use without mixing.

At right is a sampling of colors I blend together most often for watercolor lettering.

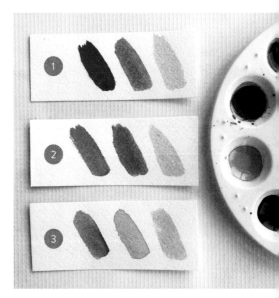

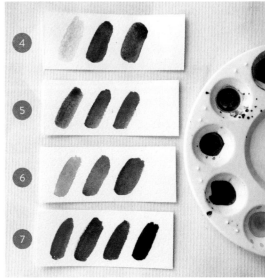

Swatches of my favorite color mixes:
1. *Sunset: red, orange, yellow*
2. *Tropical: pink, orange, yellow*
3. *Garden: blue, green, yellow*
4. *Earth: yellow, blue, brown*
5. *Unicorn: blue, purple, pink*
6. *Mermaid: green, blue, purple*
7. *Galaxy: pink, purple, indigo (or black)*

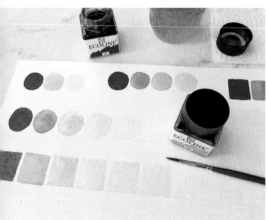

Making Swatches

A swatch is like a visual catalog of your pigments and their values. To fully understand the paints you're using, it's a good idea to paint the colors on watercolor paper and document their characteristics. Basically, you want to know what each color looks like at full strength and also when diluted with varying amounts of water. Some artists use swatches to record opacity, lightfastness, transparency, and so on.

There are many ways to make swatches, and you can be as elaborate or as simple as you want. Squares or rectangular samples are more typical swatches, but painting small circles is helpful because lettering often involves more curves than straight lines. Another method is to paint a gradient, so if you have more experience painting with watercolor, this is a good option.

What do you do with your swatches? You can organize and store them in different ways, but it's a good idea to organize them somehow, usually by brand and color. Some artists bind them together with a hole punch and ring while others place them in plastic sleeves. You can cut them apart as cards or keep them in letter size and organize them in a binder. Making and organizing watercolor swatches will help you understand colors and make better choices when you're working on your lettering projects.

1. Pick up paint from the palette and apply directly to the paper to paint the first circle as a full color wash.

2. Dip the brush into water and paint the next circle. Do not return to the palette.

3. Do step 2 repeatedly until the pigment is almost gone.

4. When dry, label the swatches with as much information as you like. I usually record only the paint brand and color name, but you can be more elaborate and add opacity, lightfastness, etc.

PAINTING WARM-UPS

The warm-up exercises on the following pages will help you get comfortable with your brush, the watercolor paint, and the application of the pigment on the paper. You'll also learn to control your hand and arm movements to produce fluid, confident strokes.

Holding the Brush

Lightly grip your brush above the ferrule. The angle of the brush to the paper can be varied to achieve different strokes.

Some lettering artists like to hold the brush upright without resting their hand on the paper or table (**fig. 1**). This allows you to use the movement of the bristles in a sweeping motion downward instead of pushing against the paper from a side angle (**fig. 2**).

The angle seems to matter most when I'm painting letters with ovals. Sometimes, I change my angle depending on what I'm writing. I also adjust the angle of my brush depending on how springy the bristles are and how they manage the transitions of thick to thin when I'm lettering a script style. If your brush has a nice spring, then you can achieve fluid lines with the side angle only. Experiment with holding your brush at different angles and see what you prefer.

NOTE: Left-handed people will adjust their paper angle and hold the brush in a way that does not cause them to smear the letters with their hands. Often an upright brush position with the hand lifted off the paper works well.

YOUR WORKSPACE

To practice watercolor lettering, a nice flat surface like a table top or desk is required with enough space for your paint palette, water cups, and paper. When I teach workshops, I remind everyone to pay attention to their posture and muscle fatigue. I sit with both feet on the floor and both arms are resting comfortably on the table.

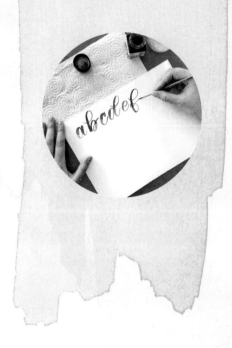

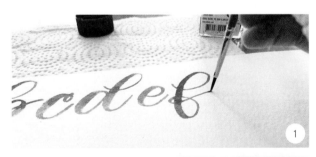

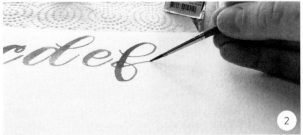

Warm-Up 1: Paint Circles

Similar to making swatches, this exercise will help you learn to manipulate your brush to paint curves and also experiment with blending colors when the different colors of circles touch each other.

1. Fill your palette with paint colors. You can use as many as you like.

2. Load your brush with water and pigment and paint a circle that's approximately 2 inches (5 cm) in diameter.

3. Clean your brush and load it with another color. Paint another circle that's a different size that touches the first circle.

4. Clean your brush and continue these steps to paint more circles that touch each other.

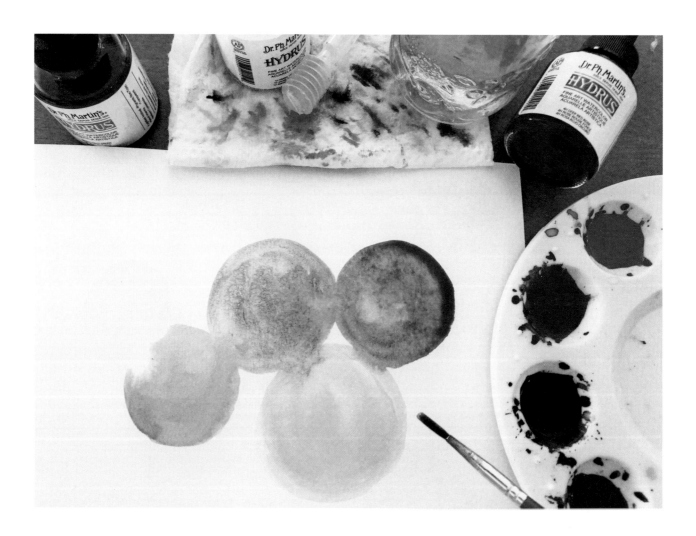

VARIATIONS

CIRCLES WITH GRADIENTS

1. Load your brush with one color and paint a large circle, filling in the left half with pigment.

2. Clean your brush and load with only water to finish the second half of the right side of the circle. This will create a gradient of color and give the circle a spherical 3D appearance.

3. Practice painting gradients from different directions, starting from the right side of the circle, starting from the top, and also starting from the bottom.

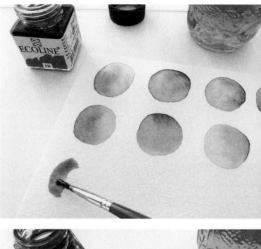

EGGS & OVALS

The egg shape is another good way to warm up and practice painting with watercolor. Managing the slightly irregular curves with a brush will help develop your skills for lettering. Try painting solid color eggs and ovals with gradients to create dimension.

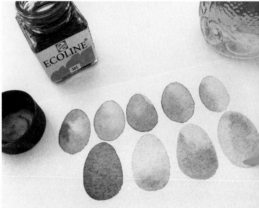

SUPPLIES

Paper (regular photocopy paper, loose-leaf paper, or watercolor paper)

Paint (any color)

Water cup

Brush (watercolor round no. 1, 2, or 3)

Warm-Up 2: Paint a Fern

Not only is this fern pretty to paint, this exercise is also a simple way to learn how to control the pressure and movement of your brush when painting longer, thin-and-thick strokes that are necessary for lettering.

1. Load your brush with paint. Near the left edge of your paper, about halfway down, paint a diagonal, sweeping line toward the top right corner (**fig. 1**). Try to move your whole arm (and not your fingers) to get a fluid, straight line.

2. Place the very tip of your brush at the edge of the stem near the bottom. Draw it outward lightly and slowly (**fig. 2**).

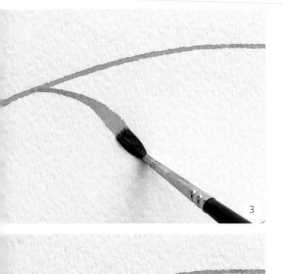

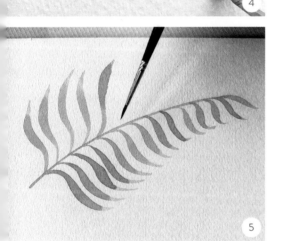

3. As you're moving the brush outward, gradually exert more pressure until almost the entire brush is lying flat against the paper **(fig. 3)**.

4. Without stopping, decrease the pressure until you end the fern leaf with the very tip of your brush **(fig. 4)**.

5. Repeat steps 2 to 4, making each leaf a little shorter than the one before until you're at the very top of the fern. Turn your paper and paint leaves on the other side of the stem using the same motion **(fig. 5)**.

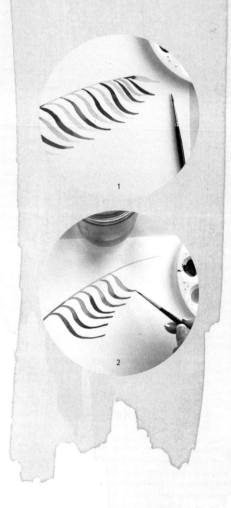

VARIATIONS

1. Switch colors between each leaf to practice cleaning your brush and changing colors.

2. This time, start with a lighter color, like light green, and add in some blue to the base or tip of the leaf to create a blended effect. *Make sure the leaf is still wet with the first color before you add the second.*

Warm-Up 3: Paint Leaves

Painting leaves involves a similar technique as painting ferns except your strokes are shorter. This warm-up helps you transition from the tip of the brush to applying pressure to the belly of the brush and then releasing again to end on the tip.

1. Load the brush with paint and place the tip of the brush on the paper (fig. 1).

2. While dragging the tip, push down until the entire belly of the brush is flat on the paper (fig. 2).

3. Continue the movement, releasing pressure until the tip is back to a point on the paper (fig. 3).

4. Add a thin line for a stem (fig. 4).

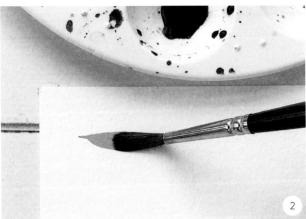

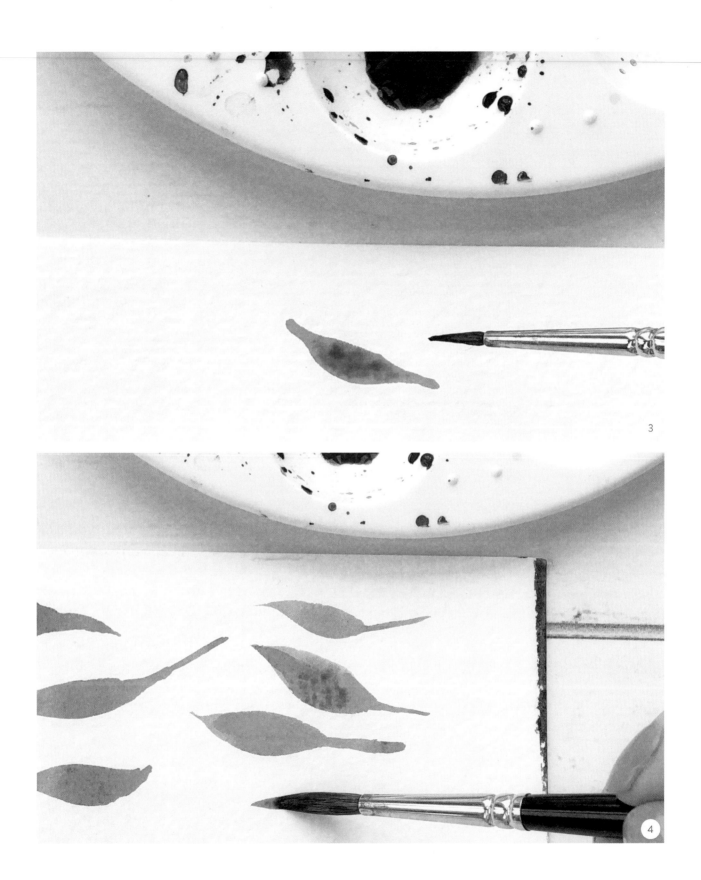

3

4

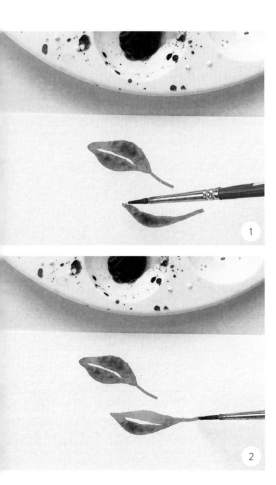

VARIATION

LEAF WITH CENTER VEIN

Leaving a space between the right and left sides of this leaf helps you practice controlling the movement of the bristles and become familiar with the response of the bristles flexing.

1. Load the brush with paint and place the tip on the paper.

2. Apply pressure while moving the brush slightly outward to the left **(fig. 1)**.

3. Release the pressure and move the tip back in alignment with the starting point. If necessary, load the brush with paint again.

4. Apply pressure while moving the brush slightly outward to the right. The goal is to leave a narrow sliver of paper unpainted in the middle **(fig. 2)**.

5. Draw a stem.

VARIATION

LEAFY WREATH

1. Paint three thin broken lines to form a circle. Use either of the leaf warm-up techniques to add leaves to these circle lines on both sides **(fig. 1)**. (Feel free to turn the paper to paint the leaves around the circle.)

2. Add tiny circles as berries, randomly around the circle and leaves **(fig. 2)**.

3. To make a card, cut out the wreath and adhere to a folded piece of cardstock **(fig. 3)**.

See page 94 for more ideas about painting wreaths.

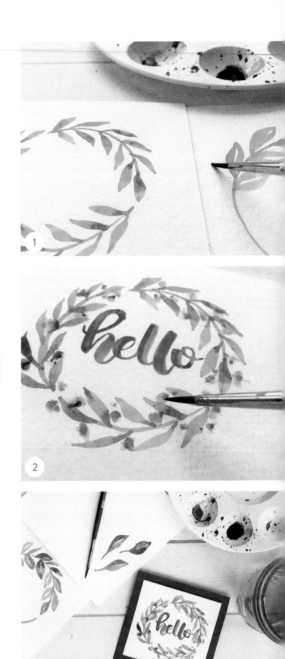

3

In Love With Letters

Hand lettering is the art of drawing letters. Sometimes, there's confusion between the definition of hand lettering and calligraphy because calligraphy is defined as beautiful writing. However, hand lettering is the *illustration* of the words rather than the *writing* of the words. For the purpose of this book, I refer to calligraphy as a brush script in which the letters are written with strokes joined together.

With watercolor, you can paint the letters as you would in hand lettering, applying paint to form the structure of letters and words. You can also use the brush to paint a script. Using a pencil to lightly sketch letters first when practicing is very helpful and using lined or graph paper is a great idea too. In this chapter, we look at a variety of lettering and calligraphy techniques using watercolor.

LETTERING STYLES

Lettering can be divided into three main categories: **sans serif**, **serif**, and **script**. The serif is the small line that is added to the end points of the strokes that make up the letterform.

Sans means *without* and is a straightforward style with a simple execution.

With just a few minor modifications, you can paint a variety of lettering styles.

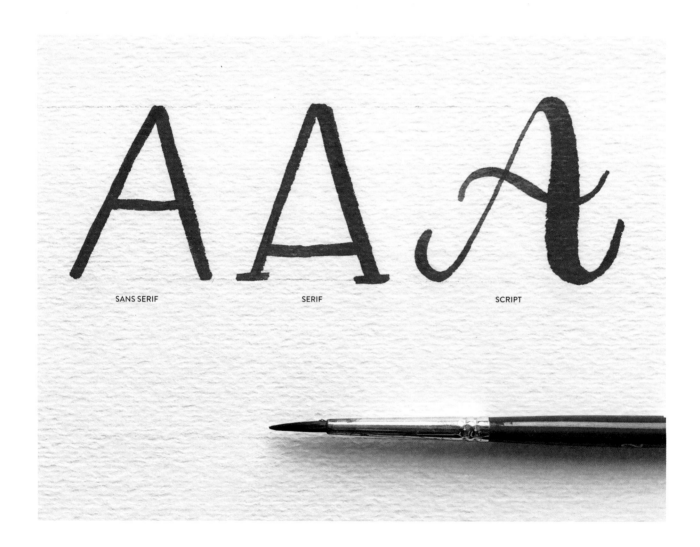

SANS SERIF SERIF SCRIPT

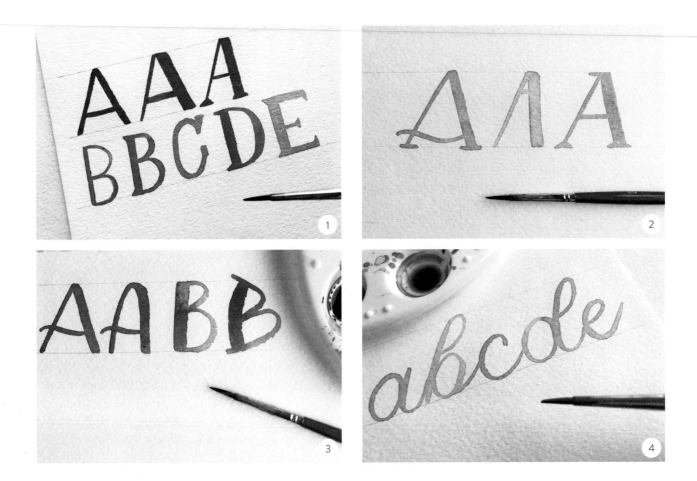

By changing the weight of some of the strokes in the serif style, we can create a new style of alphabet that mimics the Roman capitals (**fig. 1**).

Another simple modification involves moving the midline of the letters. For example, the crossbar of the A can be moved higher or lower in any of these styles (**fig. 2**).

By curving some strokes slightly, you can create another style of letters. Add some bend to the **straight stems**, which are the main vertical full-length strokes, and **ascenders**, which are the upward vertical strokes of lowercase letters above the **midline** or **x-height** (the height of a lowercase letter *x*) (**fig. 3**).

A monoline script is like cursive writing with a paintbrush. Although the letters are connected, you can pause to load up more paint whenever necessary. I also pick up my brush and pause at strategic points or natural breaks for more control over the structure and lines of the letters (**fig. 4**).

BLOCK LETTERING

Block-style lettering is achieved with wide, straight lines that look like blocks pieced together.

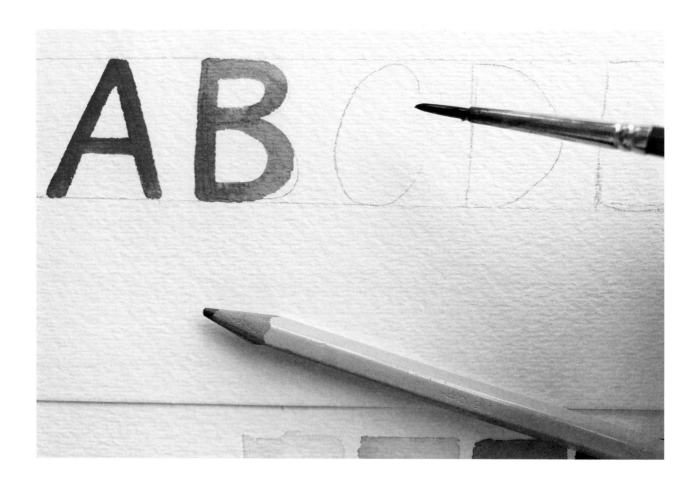

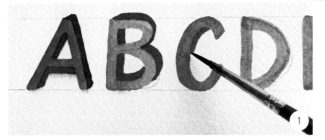

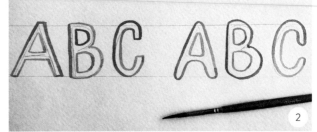

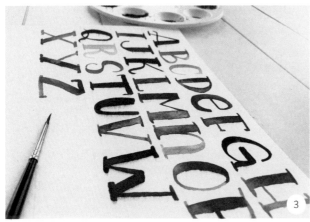

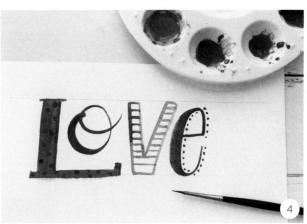

This style is often accompanied by drop shadows for dimensional effects. The shadow can be a lighter or contrasting color of the face of the letter or even another color completely. To practice, sketch the letters with pencil. Then, paint the block letter *front* and let dry before adding the dimensional shadow **(fig. 1)**.

Another option for block-style lettering is painting the outline only. One way to paint decorative letters is to add designs to the interior white space of the outlined blocks **(fig. 2)**.

When you're experimenting with hand lettering, it's a good idea to paint the entire alphabet from *a* to *z* in lowercase and capitals. This is called *curating* an alphabet. You make your own exemplar as a reference when you're painting quotes or designing lettering layouts **(fig. 3)**.

Mixing letter styles together in a single word or phrase can result in some fun, quirky, whimsical pieces of lettering art. Lots of artists also mix uppercase and lowercase together in a single word and adjust the heights of letters too **(fig. 4)**.

The best way to explore lettering styles is to sit down with your paper, paints, and brush and play! Start by using the tracing templates in chapter 7 as your guides to practice a variety of watercolor lettering styles (see page 103).

BRUSH SCRIPT

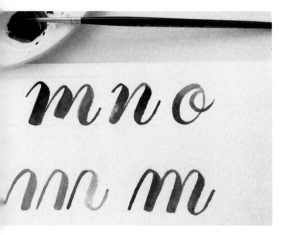

Painting a brush script involves connecting strokes and letters while manipulating the brush to create thin upstrokes and thick downstrokes. This is probably one of the most challenging lettering styles to master because you need to develop control and skill to change pressure on the brush tip while applying paint to the paper. However, because the medium is watercolor paint, you're able to correct or modify strokes that are not to your liking while you're writing each letter or word.

Although brush script *looks* like cursive, it's totally different. Using eight basic strokes, you're creating the twenty-six letters of the alphabet. Thus, learning brush script involves studying the basic strokes first and then progressing into the letters of the alphabet. Mastering the lowercase alphabet is essential before attempting the uppercase letters because the larger size and more complicated strokes of capital letters are more challenging.

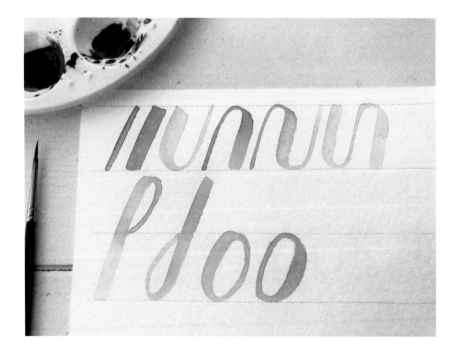

Underturn

This u-shaped stroke is used for the letters *i*, *t*, *r*, and *u*.

Overturn

If you flipped the underturn upside down, you'd have the overturn, which is found in the letters *n* and *m*.

Compound Curve

This stroke is the combination of the overturn and underturn (in that order). Use this stroke to practice *n*, *m*, *u*, *v*, *w*, and *x*.

Reverse Compound Curve

The combination of an underturn combined with an overturn creates a *connector* stroke between letters that is often used within words that have letter combinations such as *i-n* or *i-m*.

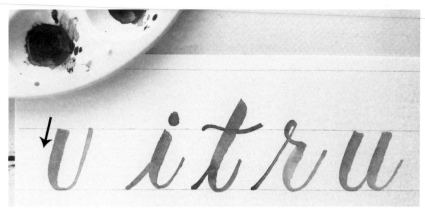

Underturn

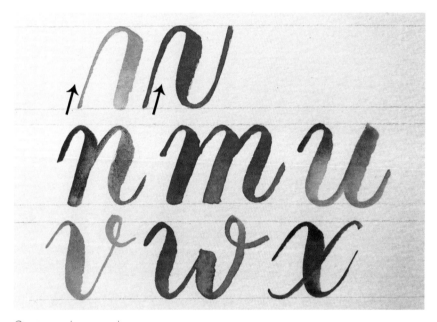

Overturn and compound curve

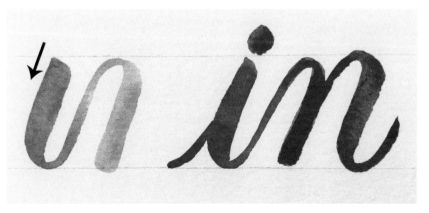

Reverse compound curve

Ascender and Descender Loops

These are the looped parts of the lowercase letters that extend *above* the waistline (ascender loops) and *below* the baseline (descender loops).

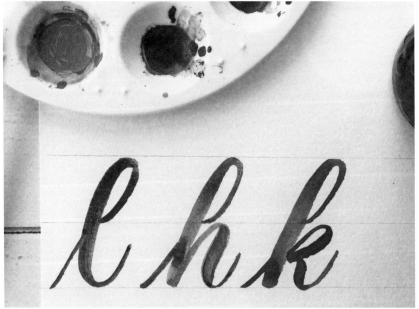

A few practice ascender loops (top), and ascender loops as shown on lowercase l, h, and k.

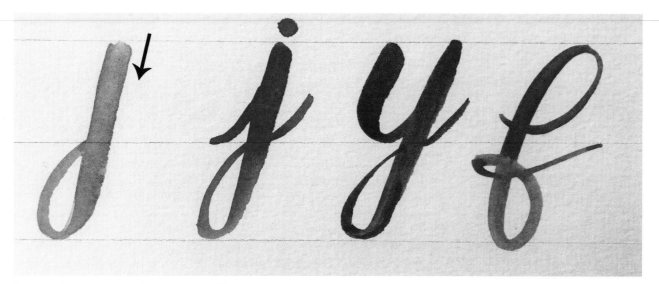

Descender loops as shown on lowercase j, y, and f.

The key to painting pretty loops is fluid lines. If you're just learning how to control your brush, then keep your loops small. Larger loops are more challenging to execute. These loopy letters should be practiced in this order from easiest to most difficult: *l*, *h*, *k*, *j*, *y*, and *f*.

ASCENDERS & DESCENDERS DEFINED

- **ASCENDER:** The part of the lowercase letters *b*, *d*, *f*, *h*, *k*, *l*, and *t* that extend above the x-height line.

- **DESCENDER:** The part of the lowercase letters *g*, *j*, *p*, *q*, *y*, and *z*, as well as uppercase *G*, *J*, *P*, *Y*, and *Z*, that extend below the baseline.

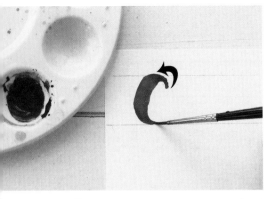

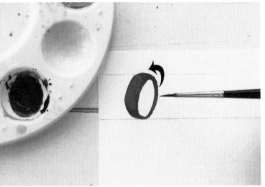

Oval

Ovals

There are two types of this stroke: **oval** and **reverse oval**.

The oval is painted in a counterclockwise direction.

By contrast, the reverse oval is painted as a clockwise brushstroke. The reverse oval can be modified to make an exit stroke that loops out to the right.

Even though the oval is the most difficult stroke to paint, the beauty of its curves is evident when painting words with a brush script. Depending on your brush and preferred grip, you can paint an oval in two ways.

Method 1. Hold the brush at a low angle as you would for the other letters **(fig. 1)**.

Method 2. Hold the brush vertically upright to paint the oval in a downward sweeping motion **(fig. 2)**.

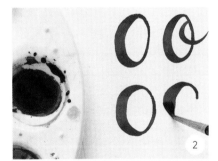

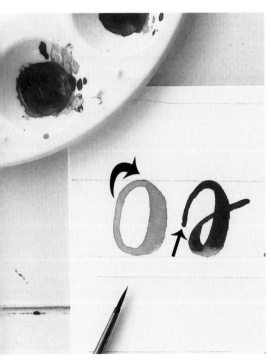

Reverse oval

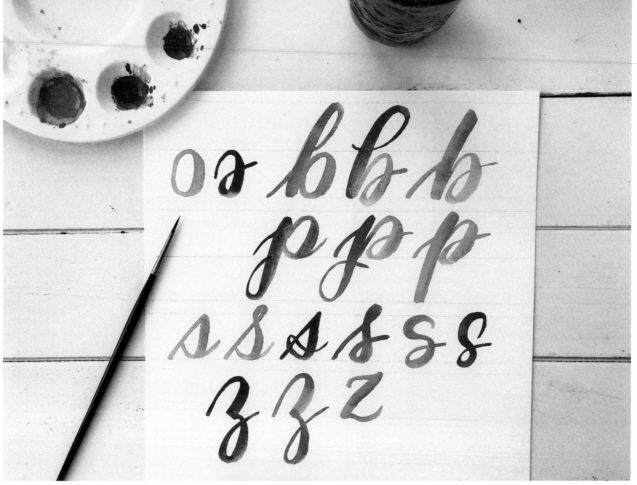

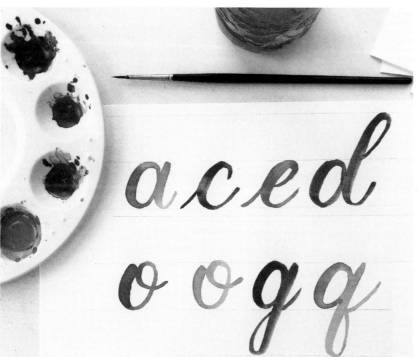

Practice these letters with ovals in this order: *o*, *a*, *c*, *e*, *d*, *g*, *q*, *b*, *p*, *z*, and *s*.

By using the brush script guides in chapter 7 (see page 103), you can practice your basic strokes and alphabets until you feel confident to paint words.

CONNECTING BRUSH SCRIPT LETTERS

Since the goal of learning brush script is painting words, it's helpful to start with simple letter combinations rather than jumping into phrases or sentences.

Begin with some of these letter combinations grouped according to the basic strokes. There are many more combinations that you can try that aren't listed here.

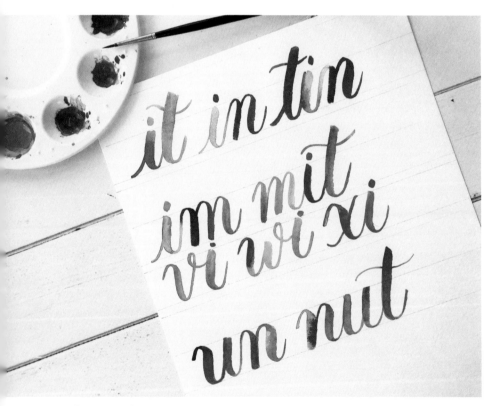

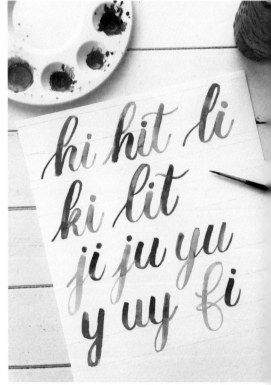

Connections featuring compound curves: in, tin, im, mit, vi, wi, xi, un, and nut.

Connections featuring underturns: it and ti.

Examples of connections featuring ascender loops: hi, hit, li, ki, and lit.

Examples of connections featuring descender loops: ji, ju, yu, uy, and fi.

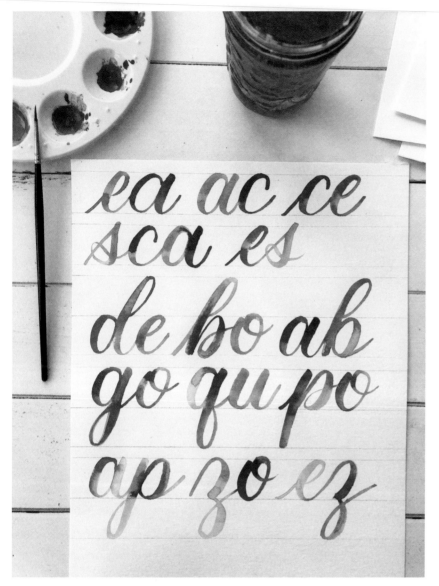

Examples of connections featuring ovals: ea, de, de, bo, ab, ca, go, qu, po, ap, sca, es, zo, *and* ez.

In chapter 7 (page 103), you'll also find some tracing practice for words and quotes. Over time, you'll develop judgment of spacing the strokes and letters to connect them successfully when lettering with watercolor. For a more detailed step-by-step instructional guide to the basic strokes and letters, please refer to my book *The Art of Brush Lettering*.

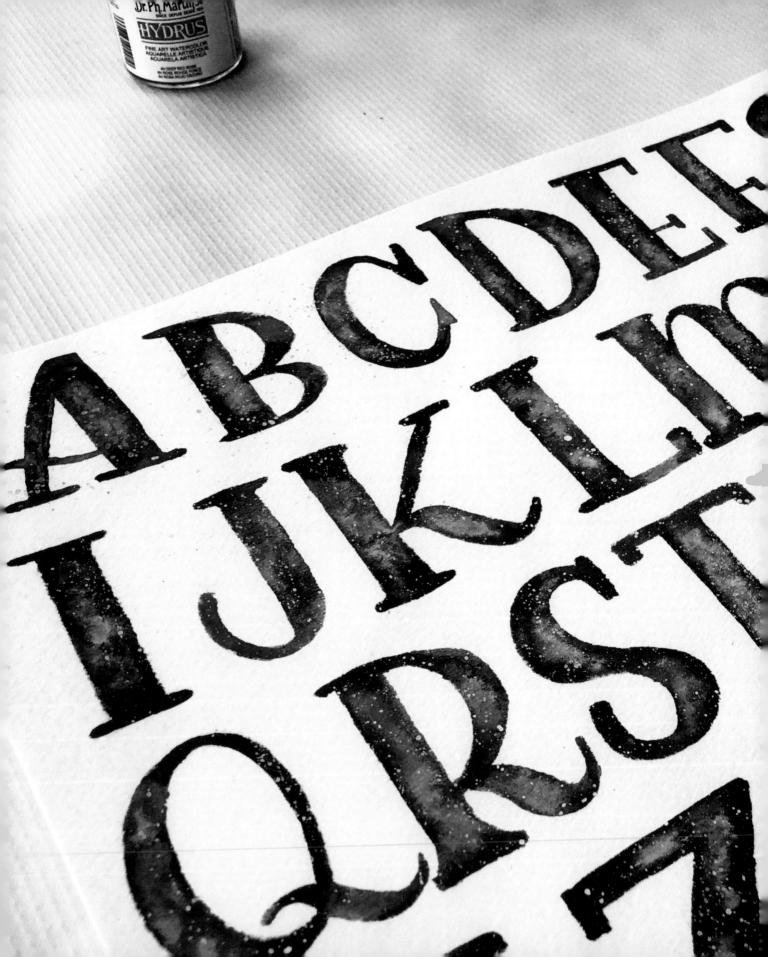

4

Color Play

Watercolor's properties as a liquid medium help us achieve beautiful results with lettering. Learn how to layer paint for monotone patterns, blend watercolor paints for rainbow and galaxy lettering, create dramatic results with metallic watercolor, achieve eye-catching white lettering, and more. Let's take advantage of the mobility of the water and create some wonderful effects with color.

WET-ON-DRY

The term *wet-on-dry* simply means applying wet paint onto the dry substrate (such as watercolor paper) or on top of dry paint. For this technique, we will paint letters, let them dry, and then paint more layers to create a pattern or an interesting effect. This is when color theory is useful and will help you design pleasing combinations of colors and patterns.

Monochromatic

Paint your letters with a light value of the color (this means add more water for a lighter hue). Let dry. Then, using the full value of the color, paint any pattern on top (stripes, dots, flowers, wavy lines, etc.).

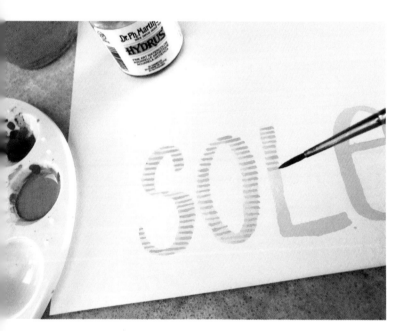
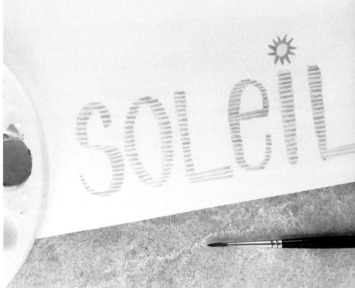

Color Combinations

Paint an alphabet or some letters with a single color. Let dry. Paint any pattern on top with other colors and discover which color combinations and patterns are pleasing.

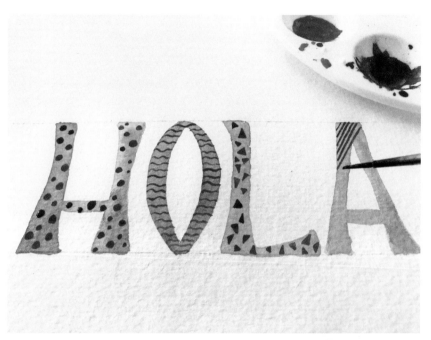

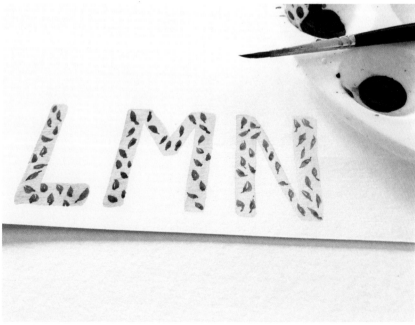

WET-ON-WET

Lettering with the *wet-on-wet* technique is mainly achieved in two ways.

Method 1: Start with Water, Then Add Paint

The first method involves applying clear, clean water to the paper first and then adding paint. You can add one or more colors, depending on the effect you want to achieve.

If your word or quote is long, and your climate is dry, then paint only one or two letters at a time with clear water and add pigment before proceeding with the rest of the word(s).

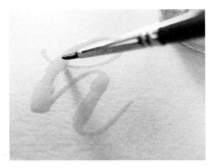
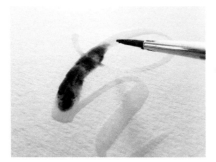

Method 1 using one color.

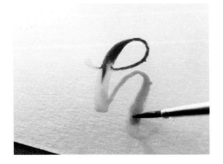
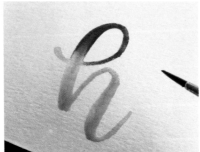

Method 1 using two colors.

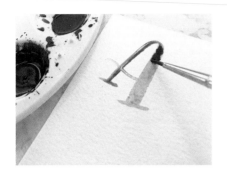
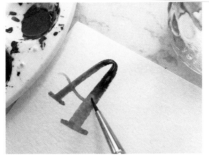

Method 2: Start with One Color, Then Blend in Another

The second method begins with one color of paint and then one or more colors is added into the first color.

Follow these steps for blending colors with the wet-on-wet technique:

1. Put the paint colors you're using into your palette.

2. Pick up the first color and paint your letter.

3. Clean your brush and pick up the second color and drop into the wet painted letter. Repeat until your lettering is complete.

You can let the paint colors blend together naturally, or you can help them move into each other with your paintbrush.

Once again, making swatches of wet-on-wet color blending will be helpful before you work on your specific lettering project. The swatches can be letters or just shapes, like the circles or squares or rectangles similar to your original paint color swatches. First, paint a circle with clear water only. Then, add colors and let them blend.

TIP: Add in a very small amount of the second color; otherwise, the second pigment will overpower the first color and blend together as solid coverage instead of drying as two or more paint colors.

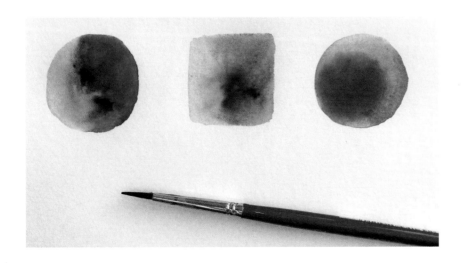

RAINBOW LETTERS

Let's look at two ways to create rainbow lettering for some really eye-catching effects. This technique can be used for combining any number of colors, not just the traditional seven colors of the rainbow.

Method 1: Alternating Paint Colors

Choose a number of paint colors that look pleasing next to each other. The color wheel is helpful for these choices, or you can just experiment and play.

Paint each letter of a word a different color. You could also paint a longer quote and alternate colors from word to word or line to line.

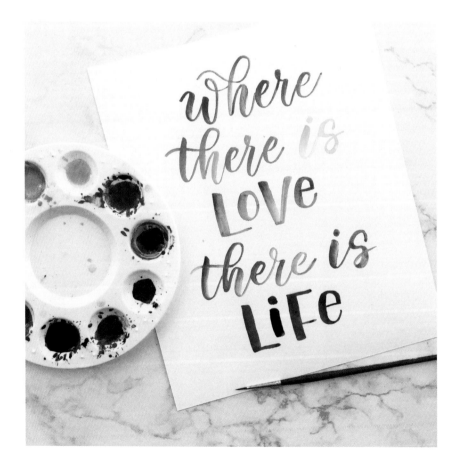

TIP: If you want the watercolor paints to blend together from one letter to the next, then the exit strokes and letters need to be wet. If the exit strokes are dry, then add a little water or paint with the tip of your brush to reactivate the paint.

Method 2: Wet-on-Dry with Script

With this technique, we work with seven colors, and the colors will blend together where the letters connect and the colors touch each other: red, orange, yellow, green, blue, purple, and pink.

Put the colors into your palette. You'll work fairly quickly so the letters are wet when you connect them. Pick up the first color and paint your first letter. Clean your brush and pick up the second color. Touch the end stroke of the first letter and paint the second letter. Continue until your word is complete.

Method 3: Wet-on-Wet with Printed Letters

A popular technique is to paint block letters that are touching each other so that paint can blend from one stroke to the next.

1. Using clear water or lightly tinted water, paint the first and second letters of the word (fig. 1).

2. Drop in your first color at the top of the letter and your second color at the bottom of the letter (fig. 2).

3. Continue this process by painting more letters or words with clear water and dropping paint into the wet letters until your lettering is complete (fig. 3).

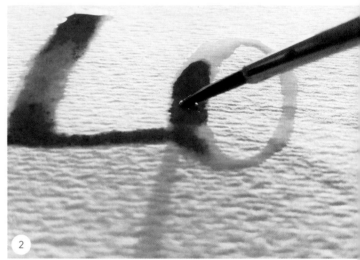

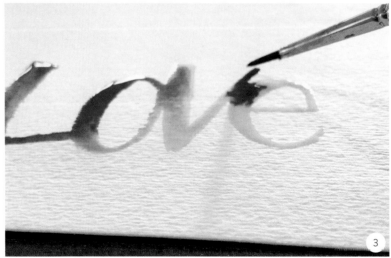

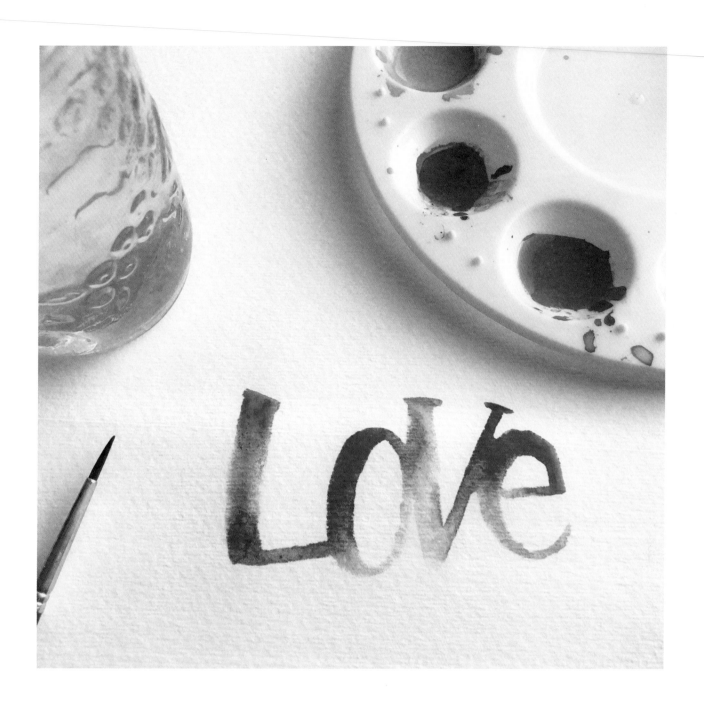

GALAXY LETTERS

I think the most fun I have when painting watercolor letters is blending colors for cool effects. One of these wonderful techniques is creating a galaxy inside the letters.

While the most popular colors used for galaxy painting are black, purple, blue, and pink, there are many more possible variations for blending pigments together to create unique and eye-catching results. Try different color combinations to make your galaxies out of this world!

You can create a galaxy watercolor effect with almost any lettering style, but I suggest larger letters with broader strokes so you can see the galaxy colors clearly, along with the white stars.

Practice: Galaxy Painting Technique

We'll use the wet-on-wet technique (see page 58) to paint galaxy letters. Let's practice by painting some galaxy circles first.

1. Use clear water or lightly tinted water and paint a circle on watercolor paper, about the same height that your letters will be. I tint my water with a touch of blue so I can see it on the paper **(fig. 1)**.

SUPPLIES

Brush (round no. 1 or 2 OR a fine- or medium-tip water brush)

Paints (black, blue, purple, and pink or green OR blue, purple, and black or indigo)

Paper towel

White gouache OR bleedproof white ink OR white (or silver) paint pen or gel pen

Optional: Old toothbrush for spattering white stars

1

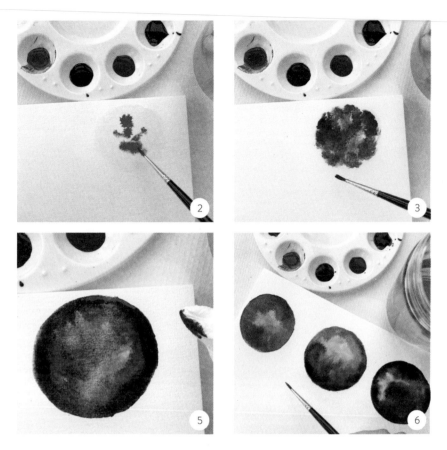

2. While the circle is still wet, use your brush to add pink (or green), blue, and purple (fig. 2).

3. Remember to clean your brush before switching to another pigment (fig. 3).

4. Add black (or indigo) around the edges and move it around a little with your brush (fig. 4).

5. Dab the center with a paper towel to lift dark pigment and create lighter areas for more dimension (fig. 5).

6. Play! Make a few different galaxy circles using different amounts of each pigment. Experiment with this technique of blending wet pigments by adding more clean water with your brush and even moving the colors around with your brush tip while the paint is still wet and flowing (fig. 6). If one of your pigments is overpowering the others, use a paper towel to pick up color while the paint is still wet. You'll discover that a little pigment goes a long way.

LESS IS MORE

- Use very little paint on your brush. You can always add more later. You're working in a small area, so a little goes a long way.

- Black can be especially overpowering, so use very little. Instead, use indigo or a similarly intense dark blue, which will create more dimension.

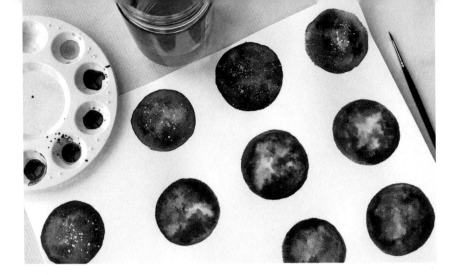

SPATTERING WITH A BRUSH

Practice spattering on scrap paper before doing it on your final project.

1. Load your brush half full with white gouache.

2. Holding the brush firmly in one hand, flick or tap the handle with a pencil or dry paintbrush so the brush shakes and paint spatters onto the paper.

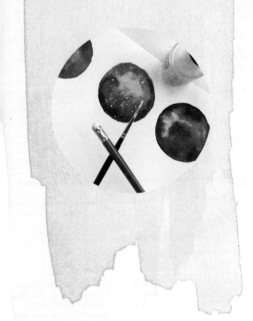

Adding Stars

Experiment with these techniques for adding white stars to both wet and dry galaxies.

- While wet, spatter with a little white gouache (see Spattering with a Brush to the left for details).

- Dip an old toothbrush into white gouache and then flick it onto your paper by running your finger over the brush bristles *toward you*.

- Add dots as stars to a dry galaxy with a white paint pen.

I prefer to let the paint dry and then spatter with gouache or manually add white dots as stars randomly. Painting white dots is time-consuming but gives you more control than a spatter or spray of white paint.

Galaxy Letters, Step-by-Step

Now, let's use the galaxy painting technique with our lettering. Before attempting to paint words, I strongly recommend that you paint the entire alphabet to practice the effect. Also, keep your letterforms fairly wide so you can create the effect with just a few colors. Otherwise, the colors won't have enough space to move and blend and will instead mix together into a single color.

1. Put black, blue, purple, green, and pink watercolor into your palette wells. Using clean or very lightly tinted water (just enough so you can see it easily), paint only one or two letters of your word at a time (fig. 1). If you paint the whole word, the water might dry before you can work with the wet letters at the end, depending on your paper and climate. (See Wet-on-Wet, page 58.)

2. Drop in a little pink (or green) pigment with your brush first (fig. 2).

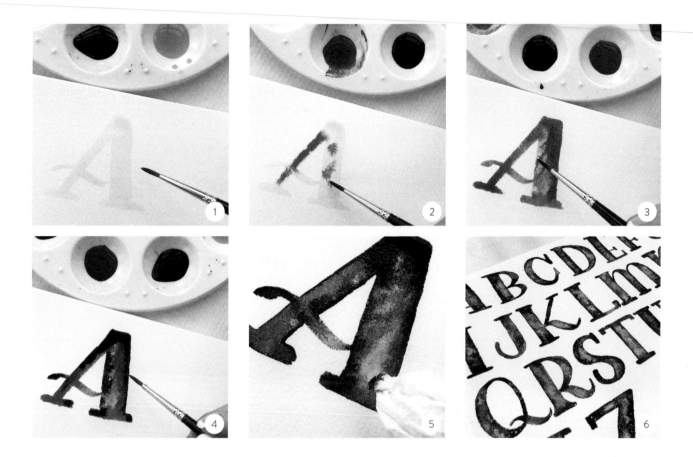

3. Add a little blue and purple and watch them blend and move together on the wet paper **(fig. 3)**. You can also add more clean water with your brush if you want more movement. But be careful not to add too much water, which might cause your colors to run into each other and become muddy or meld into a solid dark color.

4. Pick up very little black with your brush and add it to the outer edges of your letterforms **(fig. 4)**. A fine-tip brush (round no. 0 or 1) is helpful for this detailed work.

5. **Optional:** While the paint is wet, use a paper towel or dry brush to lift color and lighten the centers of your letters **(fig. 5)**.

6. For more control, I usually let the paint dry before I add stars with white gouache or a white paint or gel pen **(fig. 6)**. You can also use the spatter technique (see opposite).

LETTERING WITH PAINTER'S TAPE

Painter's tape or washi tape can be used to create clean, crisp lines and borders for your lettering projects. Not all tapes are created equal in terms of stickiness, so test the tape first.

Method 1: Block Letters

This is a great way to create some straight, clean lines with block letters, which appear simple but are tricky to draw because of all the straight lines.

1. Tape off your borders around the letters (**fig. 1**).

2. Lightly pencil in your letters. Use a ruler if necessary. If you're confident, then you can skip this step with the pencil. (Keep in mind that if you're using a very light paint color, your pencil lines will show through.)

3. Paint and let dry (**fig. 2**). Remove the tape slowly and carefully. Erase visible pencil lines.

TAPE TEST

Stick some tape onto a piece of watercolor paper. Apply watercolor paint on it and beside it and let it dry. Remove the tape slowly and carefully so as not to tear the paper. If the tape is good quality, then the watercolor paint won't seep through or under the tape.

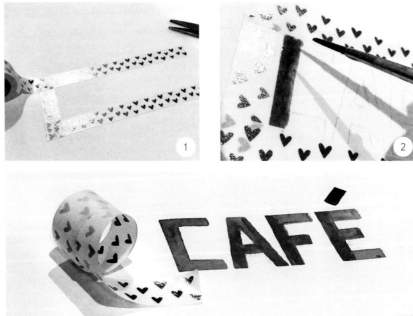

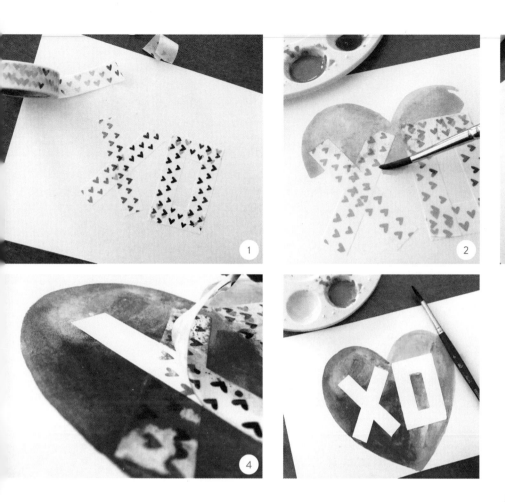

Method 2: Reverse Block Lettering

This method is more about using the tape to create the lettering design and then adding watercolor afterward.

1. Use the tape to shape the letters (fig. 1).

2. Paint your watercolor design over and around the tape (fig. 2).

3. Let dry (fig. 3).

4. Remove the tape carefully (fig. 4).

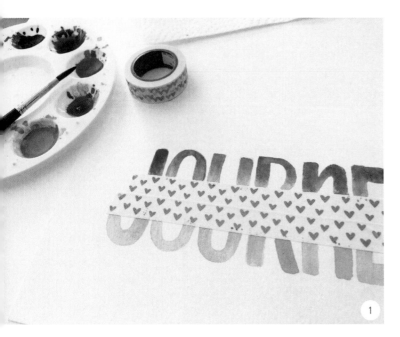

Method 3: Layered Lettering

Use the painter's tape to block off some negative space on top of a larger word for a layered, dimensional effect. This negative space can also be turned into a banner or similar design.

Note that the sample quote means "A beautiful day" in French.

1. Sketch a word with your pencil. Make it large enough so that the letters are readable even when the tape covers them.

2. Place the painter's tape across the top of the word, centered horizontally. You can choose to layer your tape according to the size of the space you want for your additional lettering (**fig. 1**).

3. Paint the word. Let dry and remove the tape (**fig. 2**).

4. Sketch out a banner that fills the space. Outline the finished design with a fineline marker (**fig. 3**).

5. Add additional lettering in the negative space (**fig. 4**).

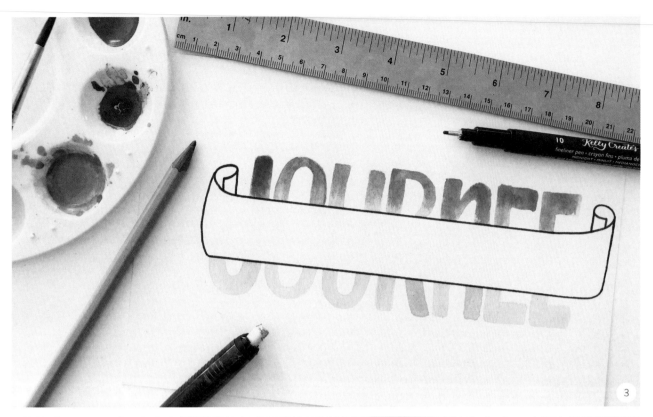

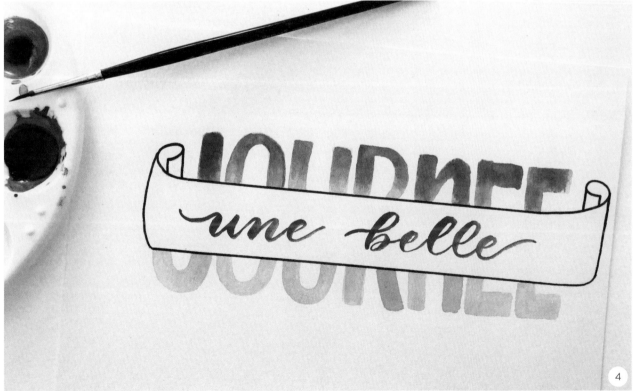

WATERCOLOR & BLACK PAPER

Painting on dark paper yields stunning contrasts for lettering projects. I've found two types of watercolor paints that work well and show up on dark paper: metallic and pearlescent. There are also some neon watercolor paints that are fun to use too.

The brightest paints seem to have a lot of shimmery mica in them and are gold and silver hues. There are some liquid inks with similar properties that are available as well.

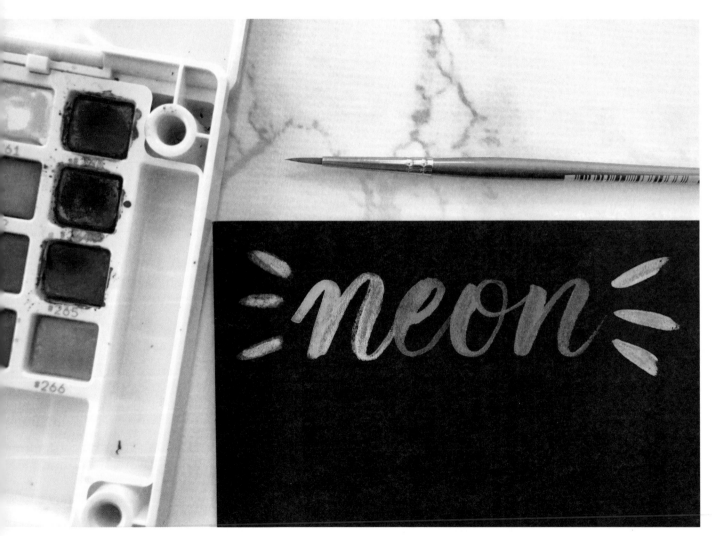

Neon watercolor on black paper.

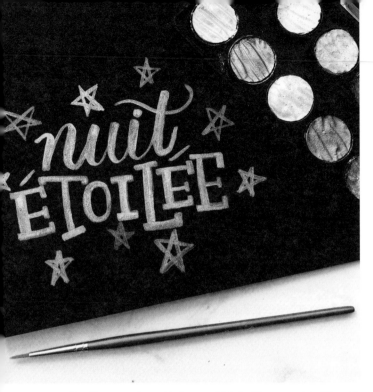

Metallic watercolor on black paper. Nuit étoilée: starry night (French).

I tend to use less water and more paint with metallic watercolors so the letters are more vibrant and have more shine. You might want to experiment with your water-to-paint ratio because of this. Also, allowing the letters to dry and then adding on another layer of paint can result in some very bright, shiny effects.

For paper, I've used smooth heavyweight black card stock; however, the better choice I've found is black Bristol paper because it's suitable for wet mediums. I'm also excited about a newly developed black watercolor paper that is now available, but I haven't tried it yet.

The challenge with black paper is using guidelines to keep your letters or words straight. Using a light pencil can work, and there are black erasers that won't leave white residue behind. You could also mark your lines with washi tape or painter's tape.

WHITE LETTERING

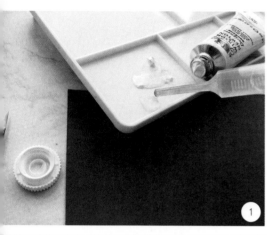

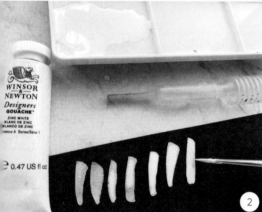

Working with White Gouache or Ink

A white watercolor paint won't be opaque enough for lettering, so I use white gouache or white ink, such as Dr. Ph. Martin's Bleedproof White. Both white gouache and white ink remain bright when painted over watercolor or onto dark paper.

You'll need to add a little water to the ink or gouache to get the right consistency to paint letters. Put the white ink or gouache into your palette and add water with a pipette until you get the suitable liquid consistency, smooth and fluid but not too heavy and thick. I use a separate palette reserved only for white paint and ink to prevent contamination from other pigments (fig. 1).

Test the opacity of your white ink or gouache with bold downstrokes on dark paper. If the white is too light, add more ink or white paint until the opacity is suitable and the paper doesn't show through (fig. 2).

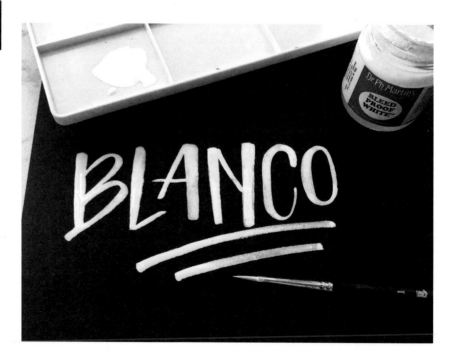

White Lettering Effects

One way to paint lettering with white is to combine it with black ink on kraft paper. This is a really pleasing color combination. Again, the paper might warp, so be careful with the amount of water you use because it's simply card stock without the properties of watercolor paper (**figs. 1 and 2**).

White lettering is also stunning on dark painted backgrounds, like a galaxy. Do a test first, if possible, to check whether your white lettering will become discolored by the background pigments. This is also a consideration if you're painting white letters onto colored card stock (**fig. 3**).

Sometimes the painted background pigments will bleed into white paint or ink, so applying more than one layer of paint might be necessary.

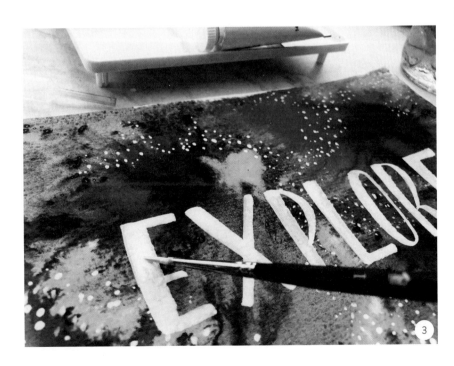

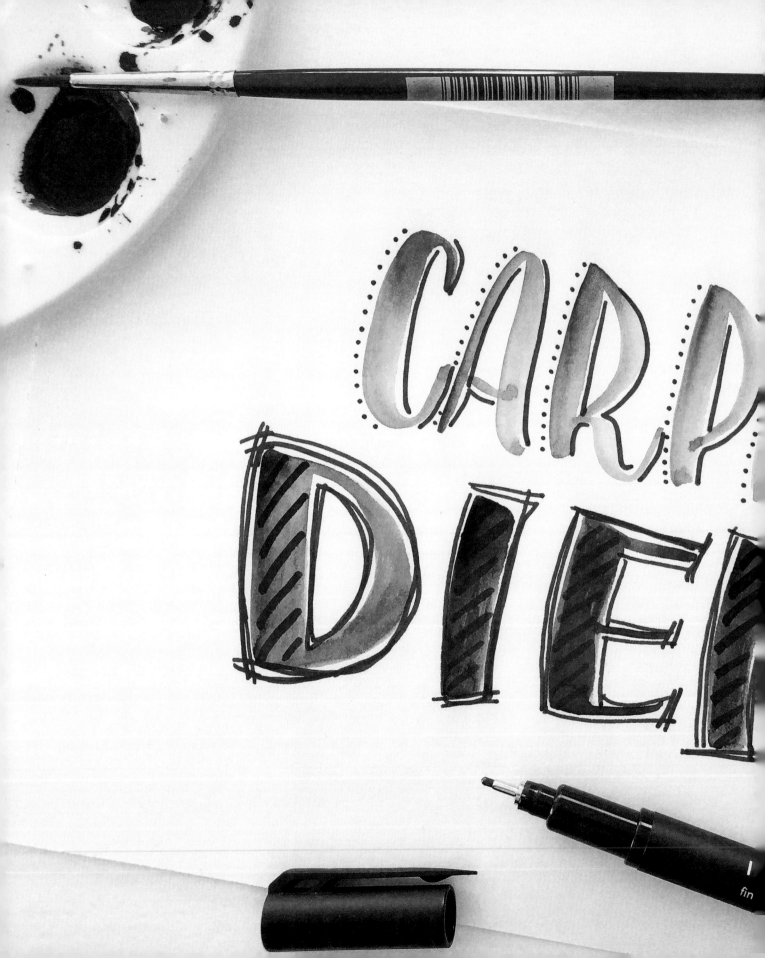

5

Creative Techniques

Watercolor lettering can be achieved in a variety of ways, not just with paint in tubes or cakes or liquids. You can create lettering with watercolor pencils, water brushes, markers, and more! Learning how to use these tools will help expand your watercolor lettering tool box when you're designing projects.

WATERCOLOR PENCILS

Water-soluble coloring pencils are a unique way to hand letter with watercolor. Many people enjoy using them because there's a feeling of more control when applying color. There are other versions of watercolor pencils in the form of watercolor *sticks* and *crayons*, which you would use the same way.

CARAN D'ACHE

(3888)
SCARLET 070

155
BLUE JEANS

WORKING WITH
WATERCOLOR PENCILS

The pigment in watercolor pencils can go a long way. Test and play with the pencils first by making swatches, just as you make swatches of your watercolor paints. Note the values of the pigments when diluted with water. Let dry, then label with the brand and color name and/or number.

You can also combine more than one color in your swatches to determine how the hues interact.

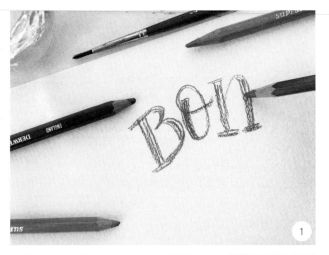

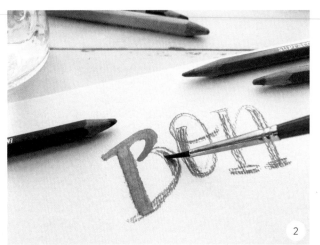

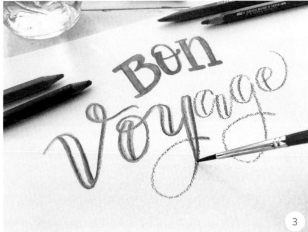

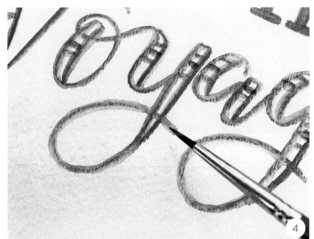

It's basically a two-step process: Draw and color your letters with the watercolor pencils (**fig. 1**), then add water with a paintbrush or water brush (**fig. 2**).

Faux calligraphy—drawing thin upstrokes and thick downstrokes to mimic brush script—is easily achieved with watercolor pencils (**figs. 3, 4, and 5**).

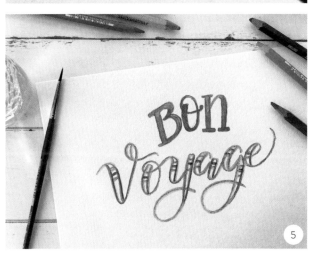

WATER-BASED BRUSH PENS & MARKERS

Brush pen calligraphy was my first venture into lettering, and I fell in love with the ease of use and beautiful script produced by the pens. I also began my journey into watercolor art using water-based brush pens. I would loosely sketch, then add water, and let the magic happen.

Similar to watercolor pencils, using water-based brush pens and markers will give you more control when drawing the letters first and then adding water later.

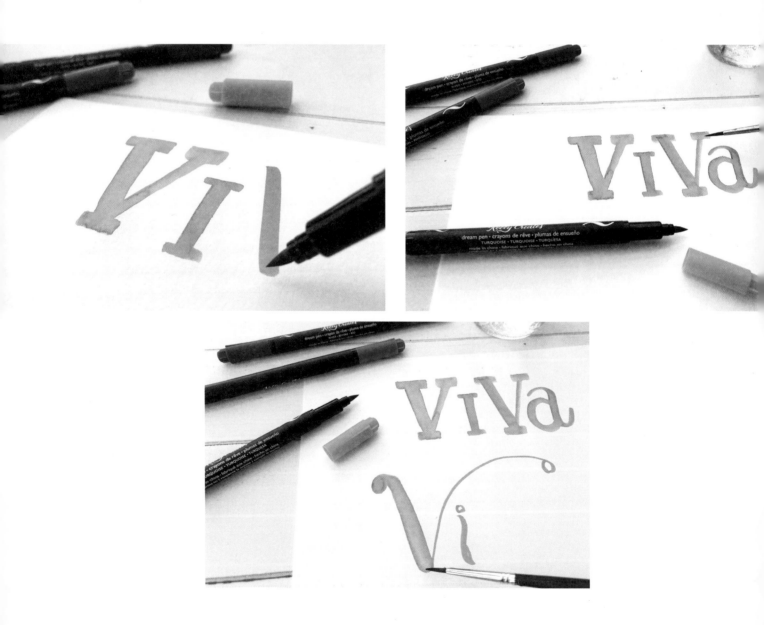

It's important to note that some pigments in water-based markers don't move as well with water, so I always test the pen colors by making swatches on watercolor paper and adding water.

Depending on your paper and your pens, you might have to do the lettering in parts, maybe even one word at a time. Otherwise, the watercolor ink will dry and might not reactivate and move when you add water.

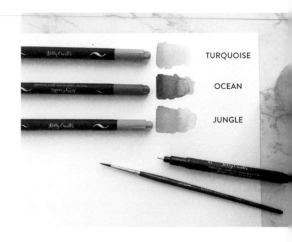

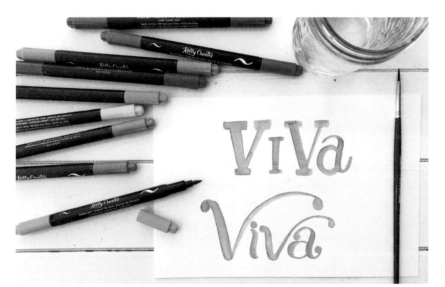

TIP: Friction and rough paper will damage your brush pen tips. I try to use Bristol paper or hot press watercolor paper that has minimal tooth and a really smooth surface.

INK & WATERCOLOR

Combining the mediums of ink with watercolor can have dramatic results for lettering. Black ink helps add definition to your lettering and can give a design a totally different look; however, any color of ink can be used.

You can experiment with lettering and ink in two ways.

Method 1: Ink First, Then Watercolor

Design your lettering first with ink only and then add watercolor.

TIP: Test your ink for permanence before using with watercolor to avoid bleeding into your wet paint. Water-based ink pens cannot be used for this technique.

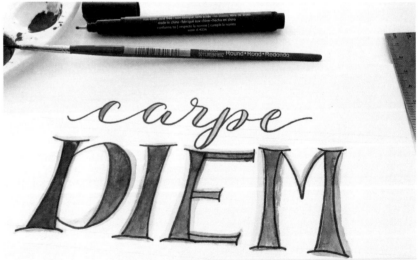

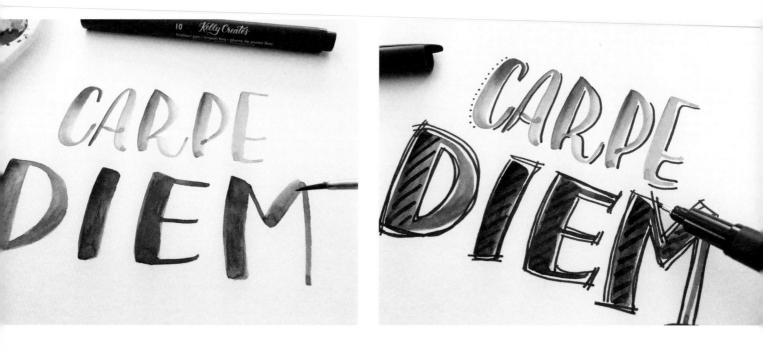

Method 2: Watercolor First, Then Ink

Paint your lettering first with watercolor and then draw with black ink.

If you're a perfectionist, then this technique might be challenging for you because you'll want to *stay in the lines* with your watercolor, and that isn't necessary for this type of lettering. Your watercolor can be outside the lines and still look wonderful, even playful or whimsical. If you have the patience and skills, then painting inside the lines is possible too.

TIP: Remember to use a piece of paper towel or cotton rag to quickly dab and *erase* mistakes if you paint outside the lines unintentionally.

MASKING FLUID & MASKING PENS

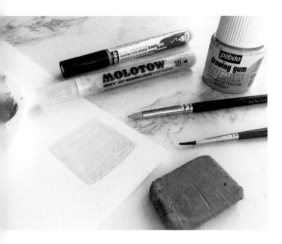

Made with rubber latex, masking fluid dries quickly, but the application can be tricky. It will dry and stick to any paintbrush, so most manufacturers recommend adding soapy water to your paintbrush before painting with masking fluid. Also, a silicone brush or tool can be used for lettering with easy cleanup because the rubbery fluid doesn't stick to silicone and wipes off readily. A wonderful alternative to masking fluid is the *masking fluid pen*, which many lettering artists enjoy using.

The purpose of masking fluid is to prevent watercolor from touching the paper or the paint that is underneath it. The key to using masking fluid successfully is complete coverage on the paper. If you apply the fluid too lightly or unevenly, watercolor paint will seep through and the lettering won't have crisp, defined lines.

I treat masking fluid as a *paint*, and use it most often to design white lettering on watercolor paper, but you can also use it on top of watercolor paint before adding more colors to your background. This results in creating an illusory effect of light watercolor painted on a dark background.

Method 1: Designing White Lettering

1. Paint the lettering with masking fluid or masking pen (**fig. 1**).

2. Paint over the top with watercolor and let dry (**fig. 2**).

3. Remove masking fluid by rubbing off with your finger or a kneaded eraser (**fig. 3**).

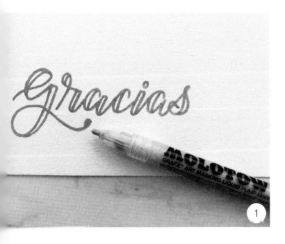

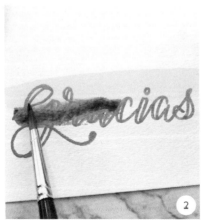

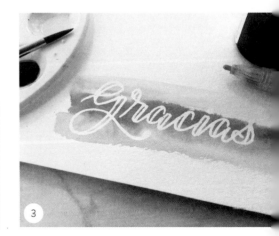

Method 2: Layering Watercolor Paint

1. Paint your initial color onto the paper that you want your lettering to be and let dry. Use the masking fluid or pen to draw your lettering and let dry (**fig. 1**).

2. Paint the background (**fig. 2**) and let dry. You can also paint with more colors and repeat steps 1 and 2.

3. Remove the masking fluid (**fig. 3**).

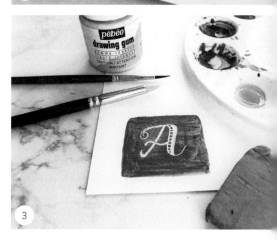

WORKING WITH MASKING MEDIUMS

- Apply masking fluid with a silicone brush or similar tool for best results. If using a paintbrush, clean thoroughly and quickly without letting the masking fluid dry. For best results, use a masking fluid *pen* for lettering.

- Remove masking fluid by gently rubbing it off with your finger or with a kneaded eraser. Make sure it's completely dry before removal.

- When layering watercolor paint, start with lighter colors as your base and then add layers of darker colors on top. Color theory is helpful when layering pigments for best results.

PREFILLED WATER BRUSHES

There are a number of brands with prefilled water brushes that have water-color paints or inks already inside the barrels. This is a really easy way to paint with watercolor, and if you collect enough water brushes, then you can create a colorful variety of letters by mixing and blending them while you paint. This is a wonderful alternative to traditional watercolor paints for those who are hesitant to manage the palette, brushes, and tubes, cakes, or liquids.

Another option to prefilled water brushes is filling your own empty water brushes with liquid watercolor by yourself. Use a pipette or an eyedropper to add the watercolor, and you can even mix more than one color inside the water brush to produce custom hues. Water can also be added to dilute the color in the water brush.

FOOD COLORING

Some artists have created lettering using food coloring instead of water-color paint. There are some neon colors and vivid pigments in food coloring that can give a powerful visual punch to lettering projects. If you want to give it a try, use food coloring as you would liquid watercolor, by adding it to your palette. You can also dilute food coloring with water if desired.

I'm not sure about the archival properties of food coloring and how much they will fade over time, so I wouldn't recommend this medium for designs that you want preserved for years.

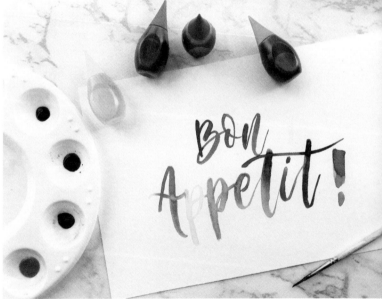

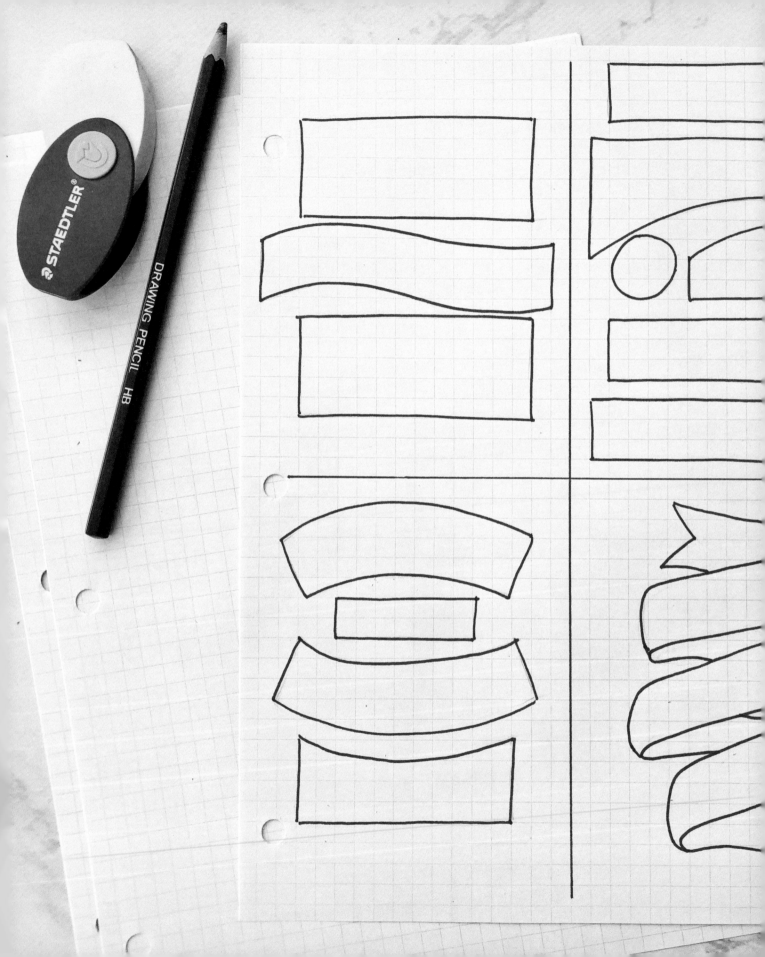

6

Dreamy Designs

After learning how to use watercolor paint and practicing some lettering styles, you can now apply your skills and create some colorful designs for gifts, home décor, cards, journals, and more.

DESIGNING & PAINTING QUOTES

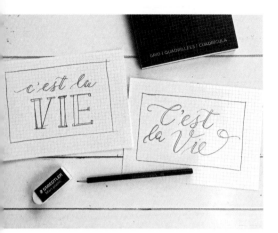

The essential tools for designing quotes: pencil, graph paper, and an eraser.

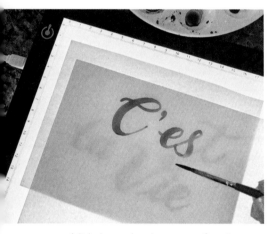

A light box makes the process of tracing and painting the final design easier.

There's a misconception that lettering artists sit down with a blank piece of watercolor paper and paint a quote from start to finish. While it's possible that someone with many years of experience will do that, most professionals spend a lot of time sketching and designing before actually picking up a paintbrush.

Tools for Designing Quotes

- The essential tool for every lettering artist is a **pencil**. Whether you're using pens or paints, lettering design work with quotes always begins with a pencil sketch.

- Another important supply is **graph paper**. You'll find the square grid on graph paper really helpful for spacing a quote's words and letters.

- An **eraser** will also be incredibly useful. A good eraser is a lettering artist's best friend. Keep in mind, though, that you're not working with one sketch. You might get the design right the first or second time, but you also might be sketching your quote a dozen times or more.

- If you plan to design quotes for home décor, cards, and other items as a business or for sale, then consider investing in a **light box**. Available online and at art supply and craft stores (and fairly reasonably priced), a light box will make quote layout and design significantly easier because you can trace and paint your final design without extensive measuring or pencil markings.

- You can practice on **regular paper** before committing your design to expensive watercolor paper, especially if your finished layout is smaller than 8½ × 11 inches (21.6 × 28 cm), which is the size of regular copy paper.

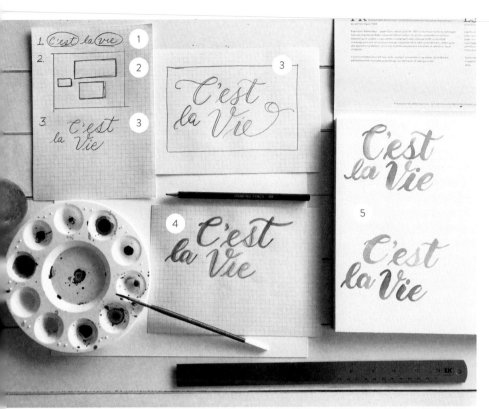

Quote Design Basics

Follow these five steps to guide your process:

1. Write the words on your graph paper and circle the words that you want to emphasize (**fig. 1**). This is very helpful when you're mixing styles of lettering and sizes of words.

2. Draw a layout of boxes, not words, to create a balanced design (**fig. 2**). This will help you judge the spacing and placement of your words.

3. Sketch the words in the layout you've chosen (**fig. 3**).

4. Practice the quote with paint by tracing over the pencil words on the graph paper and/or watercolor paper (**fig. 4**).

5. Paint the final quote on watercolor paper (**fig. 5**). Either use light pencil guidelines drawn with a ruler or a light box. (Erase the pencil lines when the paint is completely dry.)

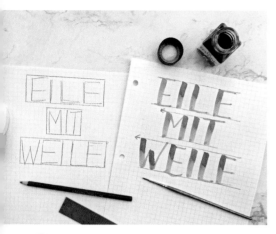

Eile mit weile: *Haste makes waste (German).*

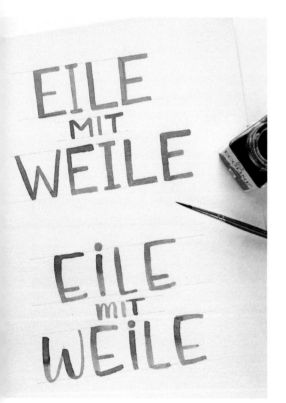

Beginner, Intermediate, and Advanced Design

Here we look at quote layout and design for three levels of difficulty—Beginner, Intermediate, and Advanced—and some helpful hints for each.

Beginner

- **Start small.** If you haven't lettered any bigger pieces before, start with short phrases of only one, two, or three words.

- **Use one style.** Letter the entire quote or phrase with the same style and size (left, top).

- **Keep it simple.** Use a simple linear or a stacked layout design, instead of elaborate shapes, banners, and embellishments.

- **Paint with one color.** This allows you to focus on the lettering and not color design.

If you're new to lettering and watercolor, then I highly recommend choosing a printed, playful style that has a loose structure. Let's look at the entire lettering process from pencil sketch to the final project on watercolor paper.

If you look at the example at left, you'll see two samples of a lettered quote. The top sample is using a very structured block capital lettering style, which can be quite unforgiving. If you look closely at the widths, of the blocks, you'll easily see inconsistencies.

However, in the bottom sample, the printed lettering is more relaxed, so the imperfections aren't important or evident.

Intermediate

- Choose one or two lettering styles.

- Change the sizes of words.

- Use a simple design with only a few words.

- Paint with more than one color.

Advanced

- Combine a variety of lettering styles.

- Compose a complex, dynamic layout.

- Play with the sizing of letters and words.

- Paint with more than one color.

- Include embellishments, such as banners, florals, etc.

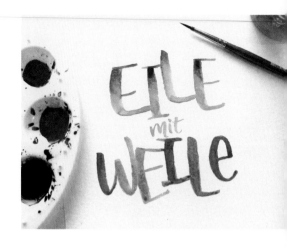

Regardless of the level of difficulty, the key to designing a visually pleasing layout is balance. The lettering styles have to complement each other and not overpower. The sizes of the words should create focal points. Most of all, the quote should be readable. Readability is my priority when lettering because I feel like it's the whole point of expressing ourselves with words. If your embellishments or lettering styles are overstimulating, cluttered, or distracting, then your message will be lost.

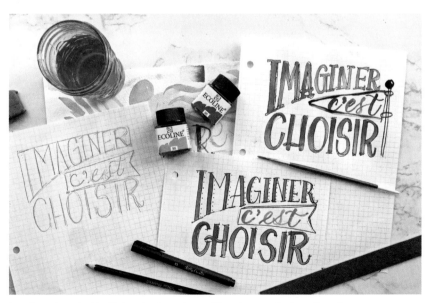

Imaginer c'est choisir: *To imagine is to choose (French; quote by Jean Genet).*

WREATH DESIGNS

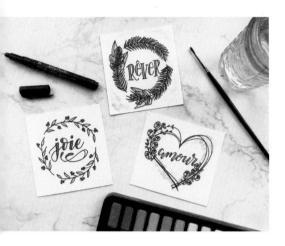

Since this book is about lettering and not watercolor painting, I'll present only a few ideas for embellishing your watercolor lettering designs with botanicals. Florals and wreaths are probably the most popular presentations of hand lettering and calligraphy. Combining ink with watercolor is a common technique when lettering with wreaths.

Wreaths can be any shape or size, depending on the lettering and theme of the words you're adding to the interior space. Circular and oval wreaths are painted most often, and I also like painting heart-shaped wreaths.

Sketch your wreath and lettering with pencil first on graph paper and practice the design before committing to watercolor paper. It's important to figure out how your lettering fits inside your wreath before you paint anything.

Before designing a wreath for your lettering, practice painting botanicals. Below are six samples that will help you paint some wreaths. You can combine these various leaves and florals in different ways with diverse colors. Flowers can be blue or purple or yellow. Autumn leaves can be red and orange. Let your imagination take over when you're painting botanicals for your wreaths and lettering.

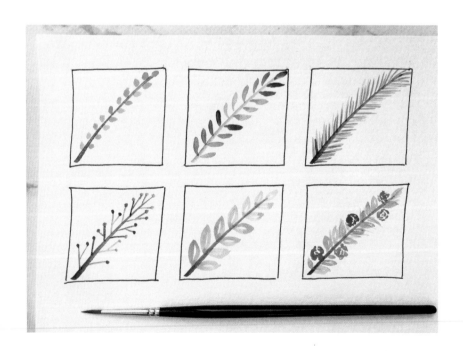

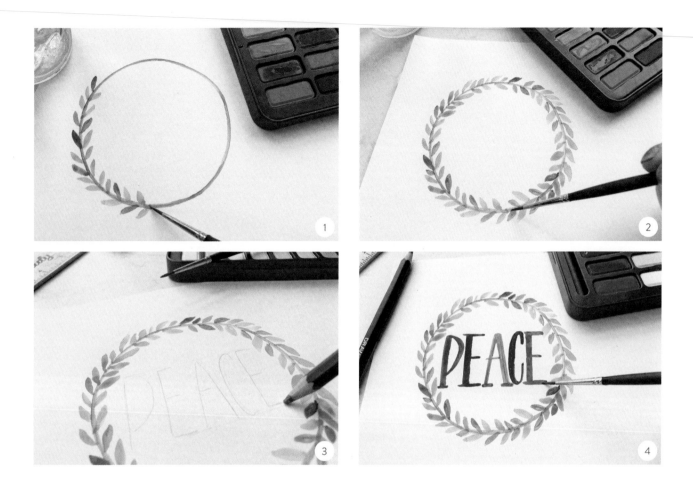

Simple Circular Wreath

The simplest wreath to paint is a closed circle with green leaves.

1. You can use a circular stencil, small plate, bowl, cup, or similar round object to help you draw a nice circle.

2. I always use two or three colors of green paint, and I also paint leaves in slightly different sizes **(figs. 1 and 2)**.

3. I add my lettering when the wreath is completely dry by using a pencil or a light box **(fig. 3)**, and then watercolor paint **(fig. 4)**.

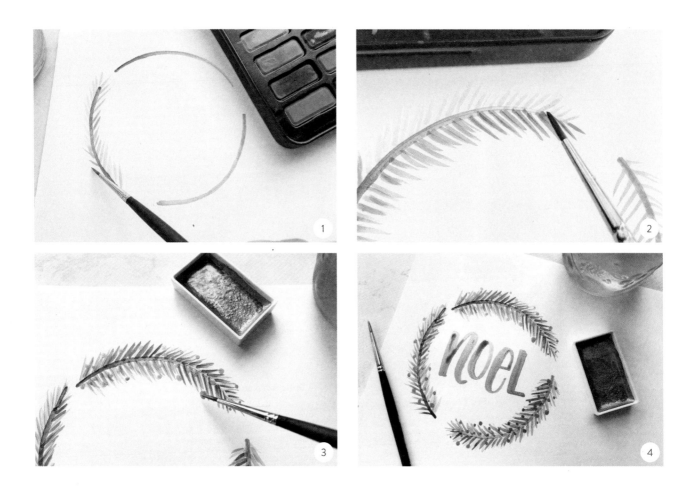

Broken Line Wreath

Another wreath design that's easy to paint consists of three broken lines, which gives the wreath a more natural shape.

1. First I paint the three lines. Once they're dry, I then paint botanicals (fig. 1).

2. For this pine branch, I layered three colors of green, which gives the pine needles dimension (fig. 2).

3. Adding some pink dots as berries gives the branches a pop of color (fig. 3).

4. Lettering with the same berry color creates harmony and unifies the design (fig. 4).

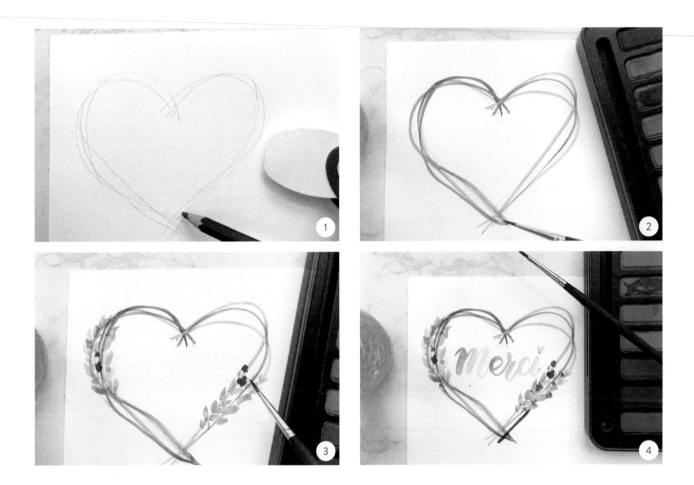

Heart Wreath

The heart-shaped wreath is easier to paint than you'd think. The trick is to paint several heart-shaped thin lines that are intersecting and overlapping. Here's my step-by-step process:

1. With a pencil, draw a heart shape several times with random lines overlapping (fig. 1).

2. Paint thin lines on top of the pencil with brown watercolor (fig. 2).

3. Add leaves and simple abstract florals (fig. 3).

4. Let the wreath dry completely before adding your lettering (fig. 4).

TIP: To speed up the process, use a wreath stamp instead of drawing or painting one. Remember to use waterproof ink so the watercolor doesn't smudge the image.

MONOGRAMS

A monogram is a single letter of the alphabet that represents someone's first or last name. One of the easiest ways to make a home décor piece, framed art, greeting card, or place card is to paint a monogram. Framed watercolor monograms make wonderful gifts!

You can blend more than one color in the monogram or use a single, solid hue. I prefer painting calligraphy-style monograms, but any style is fine.

Adding embellishments, such as florals, makes the design more elaborate and artistic **(fig. 1)**.

If you're unsure of how to paint a letter, then use the lettering styles in chapter 7 or search online for letters you like and then enlarge, print, and practice. I often use my electronic digital cutting machine to cut out larger letters as a stencil, which I then trace around with pencil before painting **(fig. 2)**.

TIP: Don't want to draw? Use floral stamps with waterproof black ink instead.

With a handful of supplies, you can easily follow these steps to design a monogram with ink and watercolor:

1. With pencil, lightly sketch a capital letter onto watercolor paper or trace around a letter template (fig. 1).

2. Sketch a floral design with a pencil on a thicker stroke of the letter (fig. 2).

3. With a permanent ink (that doesn't bleed with watercolor), trace over the floral design first and then the letter outline (fig. 3).

4. Erase all your pencil lines (fig. 4).

5. Paint either the background first or the florals. Let the first dry completely before you paint the second part (fig. 5).

FRAMING A FINAL PROJECT

You can either pop the finished piece into a frame that you purchase or have a frame custom made. Usually, I buy my own frames because my pieces are fairly small. Before you design anything, it's a good idea to have the frame in hand or at least determine the size of the finished piece. Staying within common frame measurements like 11 × 14 inches (28 × 35.6 cm), 8 × 10 inches (20.3 × 25.4 cm) and 5 × 7 inches (12.7 × 17.8 cm) will allow you to buy a ready-made frame easily.

CREATING DIMENSION

Adding shadows to your lettering can create wonderful dimension. Shadows can be thin lines, thick lines, or even both, made with watercolor paint or even markers and pens.

The most common colors for shadows are gray and black; however, any color can be used. The shadow can touch the edges of the letters and strokes or you can leave a gap.

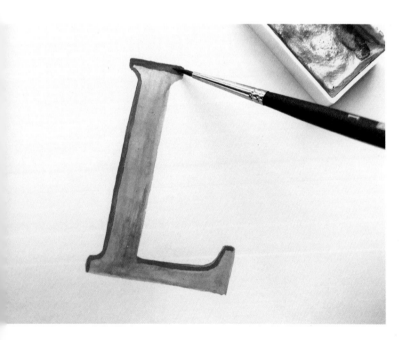

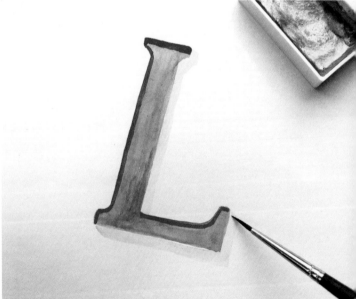

There are a variety of ways to add shadows to letters, but what's most important is imagining a light source. My imaginary light source is usually on my left, so I mostly add shadows on the right edges of letters.

I really like to add shadows with pens because I feel like I have more control, but no matter the medium, always wait for the wet letters and words to dry completely before adding shadows. Here is a helpful exemplar of an entire alphabet with shadows on every letter.

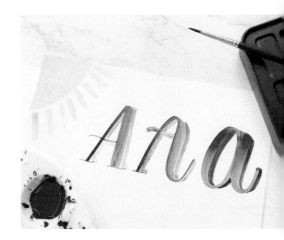

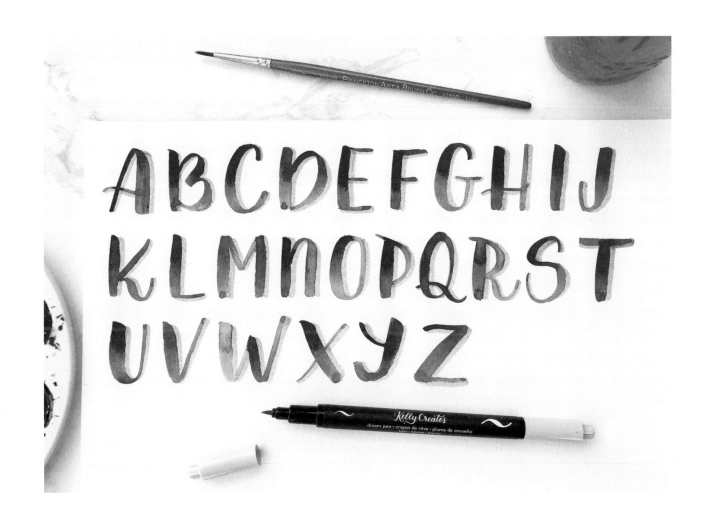

GHIJ
MNO

ABCDE
FGHIJ
KLMNO
PQRST
UVWXYZ

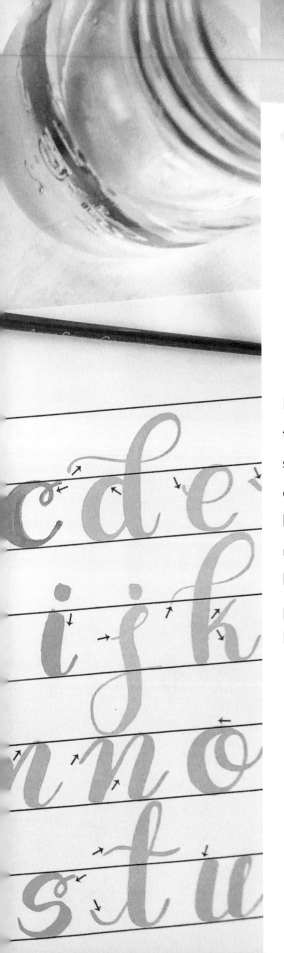

7

Trace & Learn

How do we learn a variety of lettering styles with watercolor? By tracing the alphabets. In the pages that follow, you will find brush script worksheets for repetitive practice. There are also exemplars of other alphabets that will help you develop an understanding of how to paint different styles, block, serif, sans serif, decorative and more. Plus, I've added words and quotes that allow you to progress beyond painting alphabets and move toward design concepts. By practicing with these guides, you will be on your way to creating beautiful, artistic watercolor lettering!

Begin at the arrow and follow the direction.

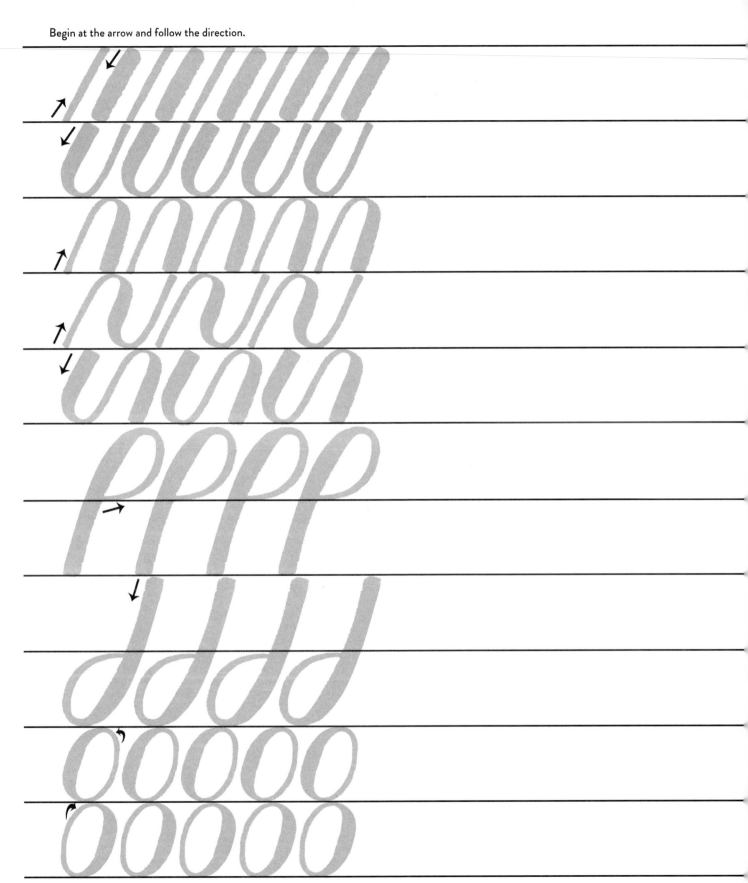

REMOVE SHEET ALONG THE BINDING. PAINT DIRECTLY
ON THE SHEET OR PHOTOCOPY TO MAKE MULTIPLES.

BRUSH SCRIPT: BASIC STROKES | 105

Follow the arrows and adjust pressure on your brush to paint thick and thin strokes.

a b c d e f
g h i j k
l m n o p
q r s t u v
w x y z

REMOVE SHEET ALONG THE BINDING. PAINT DIRECTLY
ON THE SHEET OR PHOTOCOPY TO MAKE MULTIPLES.

LOWERCASE BRUSH SCRIPT: ALPHABET | 107

Follow the arrows and create thick and thin strokes by applying pressure on your brush.

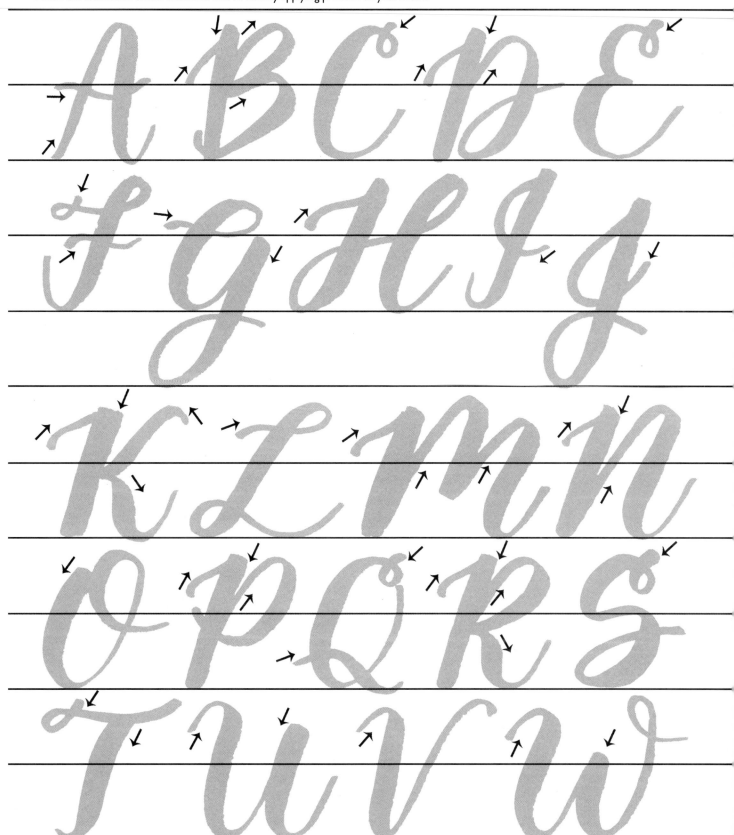

REMOVE SHEET ALONG THE BINDING. PAINT DIRECTLY
ON THE SHEET OR PHOTOCOPY TO MAKE MULTIPLES.

UPPERCASE BRUSH SCRIPT: ALPHABET LETTERS A TO W | 109

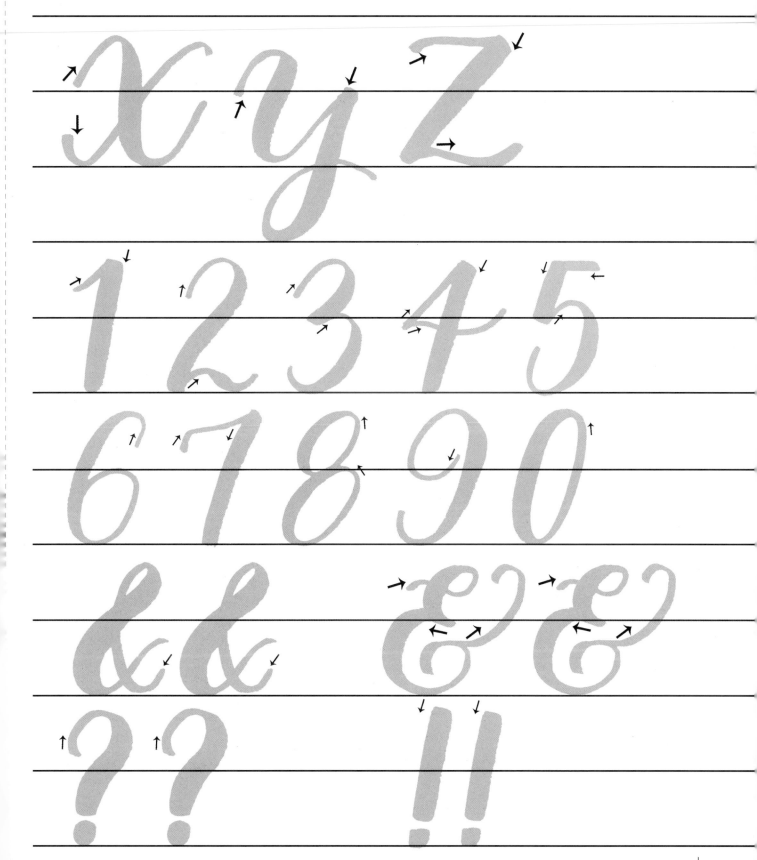

Using a round 1 or 2 watercolor brush, paint the following words.

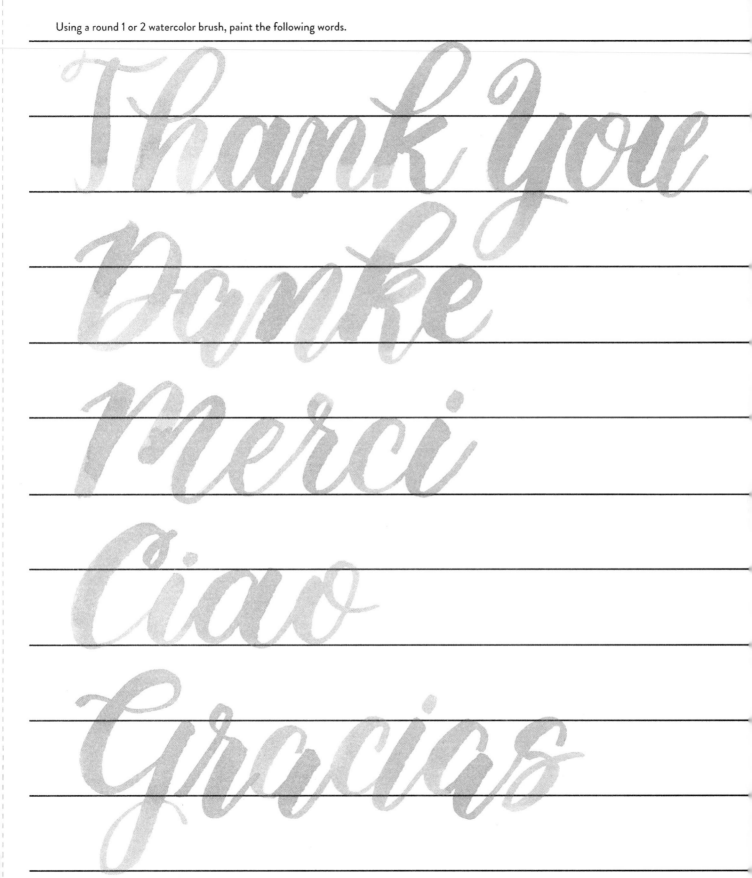

Thank You

Danke

Merci

Ciao

Gracias

Practice painting this alphabet (dark gray) and let dry completely. Then, paint shadows where you see lighter gray along the edges. Use light gray paint or any contrasting color for the shadows. You can also use a lighter value of the original color you used.

ABCDEFGHIJ
KLMNOPQRST
UVWXYZ

ABCDEF
GHIJKLM
NOPQRST
UVWXYZ

Curve your serifs and paint thick and thin strokes to create this alphabet.

ABCDEF

GHIJKL

MNOPQR

STUVWX

YZ

Focus on painting the rectangular *blocks* the same size for every letter to keep a unified structure.

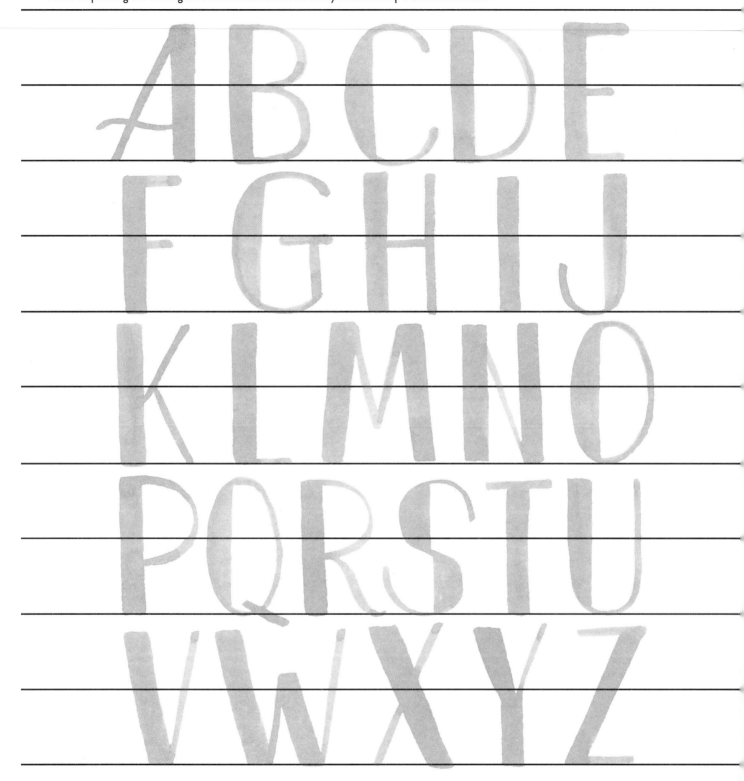

REMOVE SHEET ALONG THE BINDING. PAINT DIRECTLY
ON THE SHEET OR PHOTOCOPY TO MAKE MULTIPLES.

SIMPLE BLOCK ALPHABET | 119

Paint this decorative style to practice your finesse with the brush tip. Fill in with paint, patterns, or leave as outlines. Take your time with the spurs (the small projections off the main strokes) and split (bifurcated) serifs.

A B C D E

F G H I J K

L M N O P

Q R S T U

V W X Y Z

Paint this playful style with a mix of uppercase and lowercase letters.

a B C D E F

g H i J K L

M N O P Q

R S T U V

W X Y Z

Use a quick brushstroke to achieve a distressed appearance.

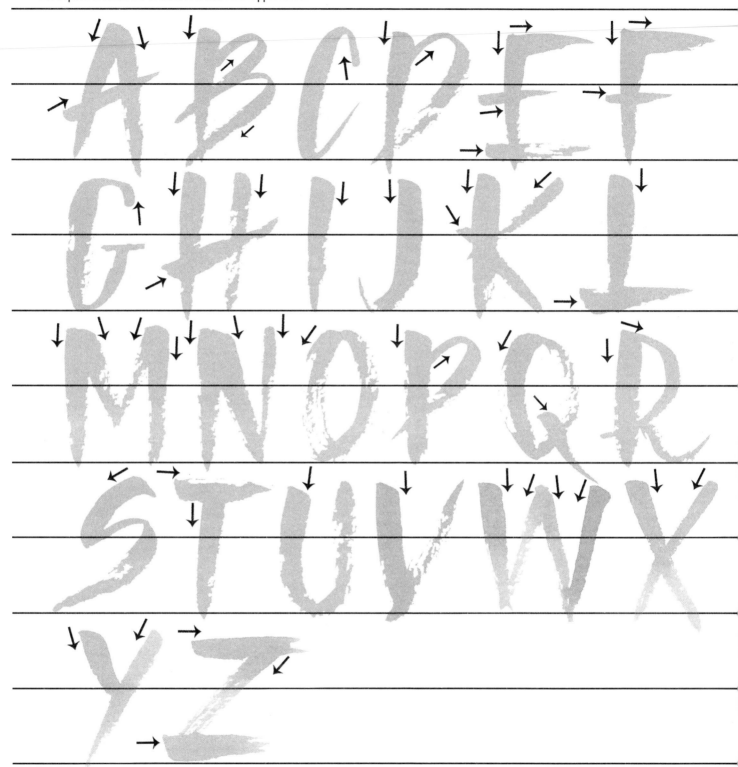

REMOVE SHEET ALONG THE BINDING. PAINT DIRECTLY
ON THE SHEET OR PHOTOCOPY TO MAKE MULTIPLES.

YARD SALE ALPHABET: WET-ON-DRY | 125

Paint block letters with identical stroke widths.

A B C D E

F G H I J

K L M N O

P Q R S T

U V W X Y Z

Practice outlining these block letters using only the tip of your brush.

A B C D E

F G H I J

K L M N O

P Q R S T U

V W X Y Z

Learn to control your brush with these structured serif letters.

A B C D

E F G H I

J K L M

N O P Q

R S T U V

W X Y Z

REMOVE SHEET ALONG THE BINDING. PAINT DIRECTLY ON THE SHEET OR PHOTOCOPY TO MAKE MULTIPLES.

VINTAGE TYPEWRITER ALPHABET | 131

Use the rainbow blending technique to paint the letters.

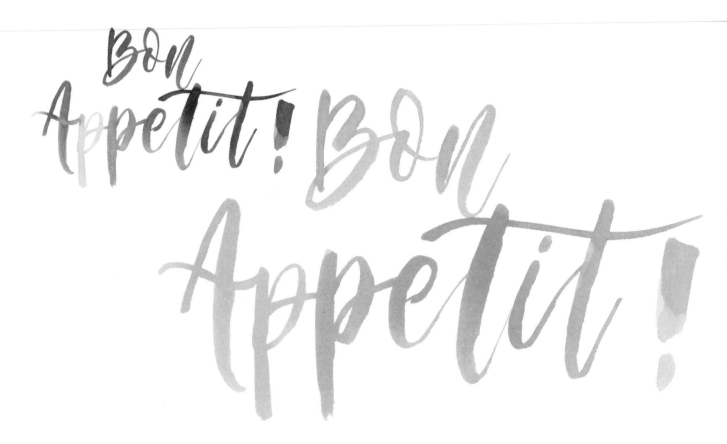

First, paint the letters and let dry completely. Then, add outlines and accents with black ink.

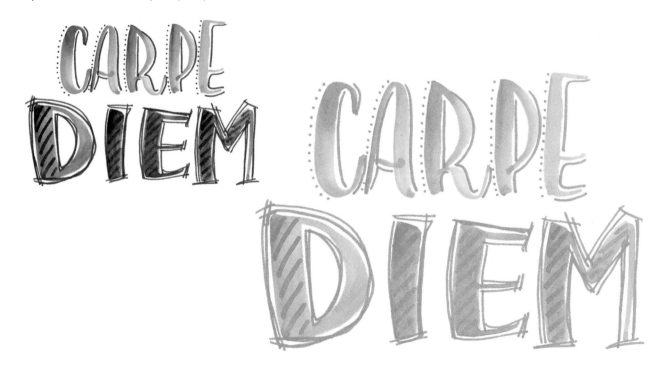

Paint the leafy wreath and let dry. Then, paint the letters inside.

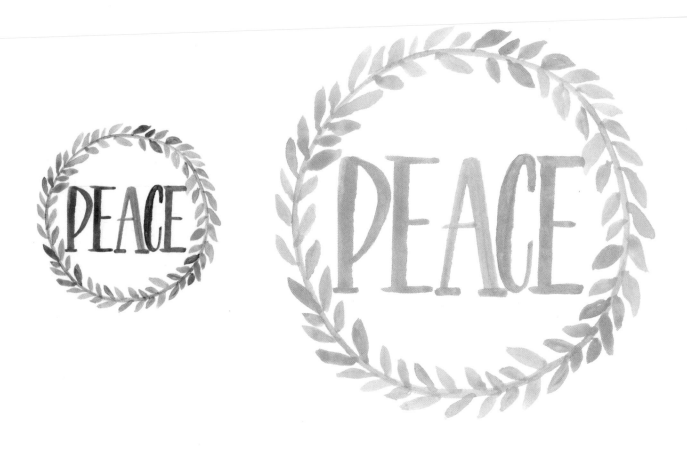

Paint one letter, let dry, and then add its drop shadow. Let dry completely before moving on to the next letter.

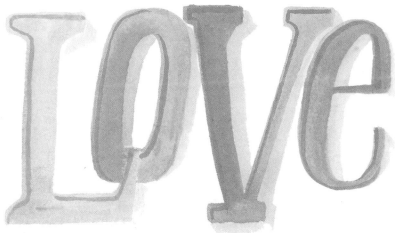

Practice your layout design skills by painting letters on an angle and within a banner. Quote: To imagine is to choose (Jean Genet; French).

IMAGINER
c'est
CHOISIR

IMAGINER
c'est
CHOISIR

Paint an alphabet heart using watercolor. Practice blending different hues to create a beautiful, vibrant piece of art.

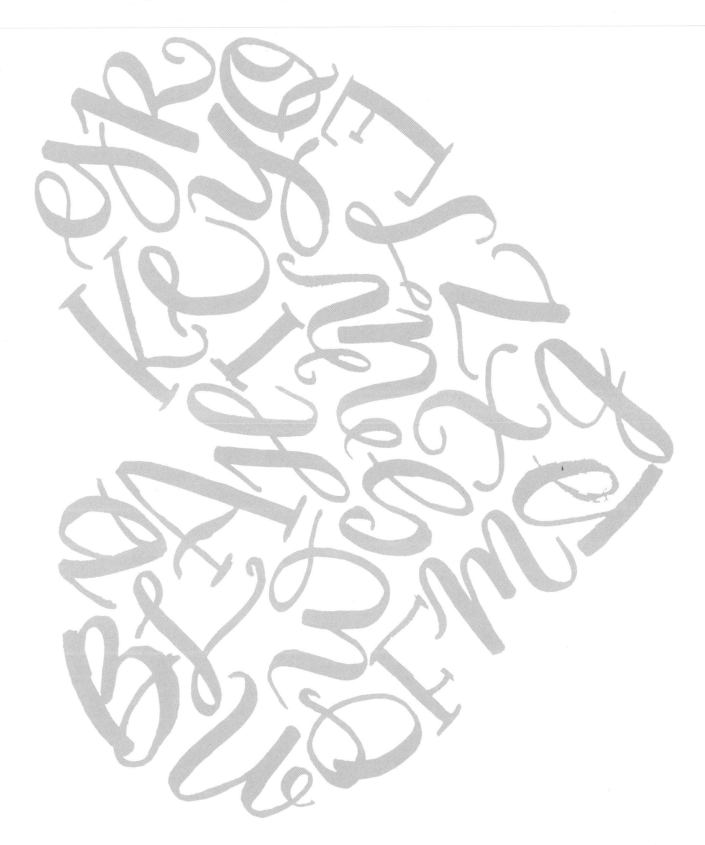

REMOVE SHEET ALONG THE BINDING. PAINT DIRECTLY
ON THE SHEET OR PHOTOCOPY TO MAKE MULTIPLES.

BLANK PRACTICE SHEET | 141

ACKNOWLEDGMENTS

Becoming an author was a dream come true. I feel so blessed that I have another opportunity to share my love of lettering through this new journey. Writing a book has lots of highs and lows; it is incredibly rewarding but also stressful. I would like to thank all of you who encouraged and supported me in writing this second book. My husband, Elmar, is always there when I need reassurance and listens to me whenever I need a sympathetic ear. I am grateful for my children, Matthew, Serena, and Mila for understanding how much it means to me to be an author and giving me the space and patience to do so. My dear friend Crystal Edwards is my assistant and always has my back on this wild calligraphy ride. I am so grateful to my team at Quarto (Joy, Nyle, Heather, Lydia), who accommodate my travel and workshop schedule and pushed back deadlines so I could meet them.

ABOUT THE AUTHOR

The author of *The Art of Brush Lettering* (Quarry Books, 2017), **Kelly Klapstein** is the founder and owner of Kelly Creates, an online provider of instruction and inspiration for artful lettering. After a decade of teaching high school English, along with writing and developing curriculum, Kelly now runs her site and lettering business full time. She is also a designer and writer for *Creative Scrapbooker* magazine and travels and teaches workshops around the world, sharing her love of lettering with a global creative community. Her lettering product line, manufactured and distributed by American Craft, was launched in December 2017 and is available in stores internationally. She lives in Edmonton, Alberta, Canada, with her family and dog Finn, who loves to steal her pens.

INDEX